HOW TO PAINT
FLOWERS IN
WATER COLOUR

Dedication

*I dedicate this book to my husband Tony Nutt
and our daughters Sophie and Suzie.*

HOW TO PAINT
FLOWERS IN WATER COLOUR

JULIE KING

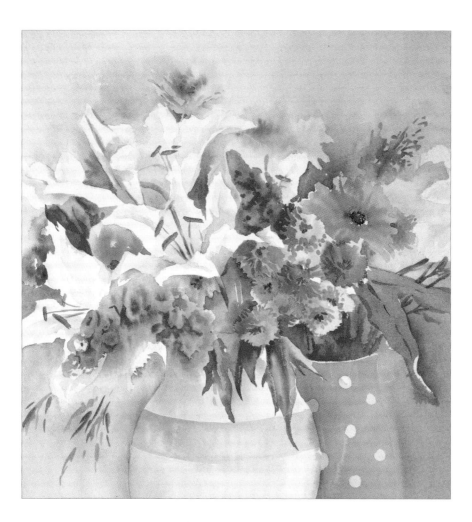

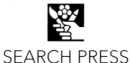

SEARCH PRESS

First published in Great Britain 2008

Search Press Limited
Wellwood, North Farm Road,
Tunbridge Wells, Kent TN2 3DR

Suppliers
If you have difficulty in obtaining any of the materials
and equipment mentioned in the book, please visit
www.winsornewton.com for details of your nearest
Premier Art Centre.

Alternatively, please phone Winsor & Newton Customer
Service on 020 8424 3253.

Publishers' note

All the step-by-step photographs in this book feature the
author, Julie King, demonstrating water colour painting.
No models have been used.

You are invited to visit the author's website at:
www.juliehking.co.uk

Acknowledgements

*I would like to thank Roz Dace for
commissioning me to write this book,
which has led me to fulfil a dream.*

*To my editor Edd Ralph, thank you for your
guidance, patience and humour, along with
Debbie Patterson who made the photographic
sessions enjoyable.*

*Thank you to all my students and friends for
your support and encouragement.*

*To my family for your love and support
enabling me to pursue my passion for art.*

Printed in Malaysia

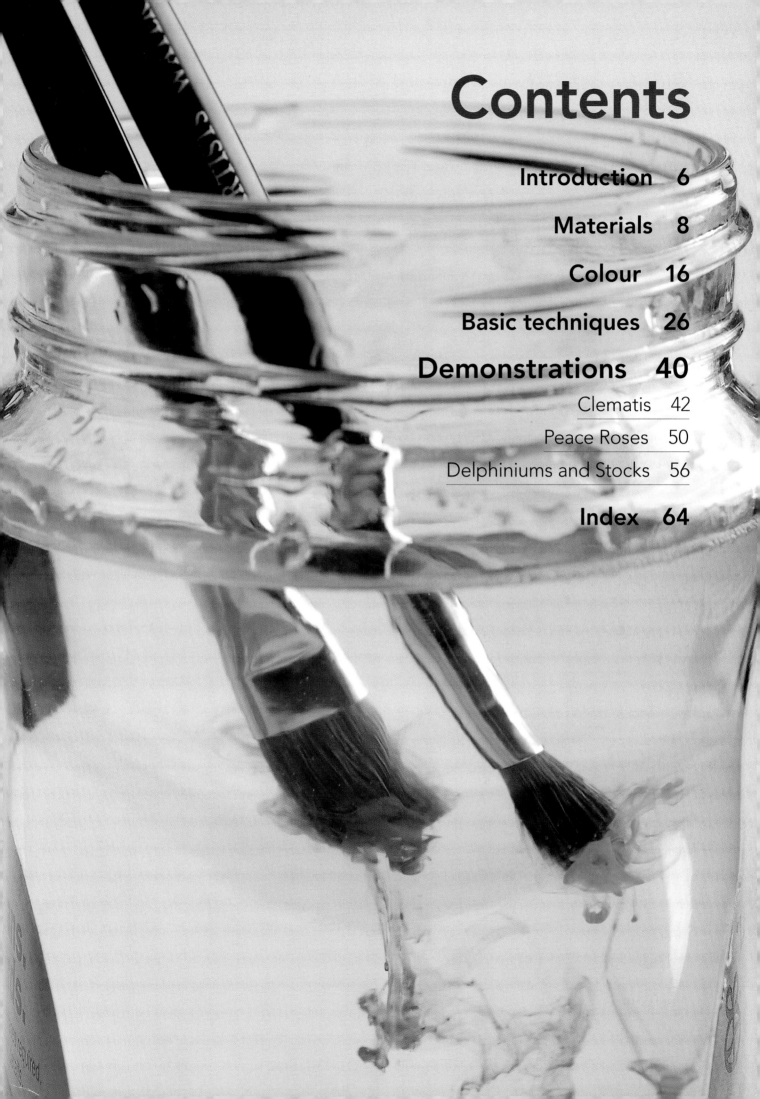

Contents

Introduction

Flowers have always fascinated me and inspired me to paint. Since childhood I have been attracted to the exuberant colours, shapes, textures and fragrances in nature, and aware of the beauty of the world surrounding me. I can still visualise and smell the scent of the mass of roses entwined on the trellis and the tiny, delicate and equally beautiful blue forget-me-nots in the borders of my family home. A passionate gardener, my mother ensured I grew up surrounded by a canvas of colour.

Driven by my love of nature I was eager to put pencil and paint to paper. On my sixteenth birthday I received a box of Winsor & Newton water colour paints which was the beginning of a passion. Opening that little box has led me to a fulfilling career as an artist, designer and teacher. It was and still is my most treasured possession, accompanying me everywhere.

Over time, I have refined my colour palette to suit flower painting, choosing mainly transparent colours to evoke their delicacy. In this book I show which colours I use and why, along with the basics of colour theory, which are of primary importance when learning how to paint.

Having trained and worked as a printed textile designer, I have combined my painting and visualising skills to create my own individual style which I will share with you.

When I look at flowers, I respond to their beauty. They are alive, and my aim as a painter is to capture that flow of vitality. Being able to understand and feel the essence of the flowers and visualise what lies beyond the basic techniques of painting is important to me. I hope to demonstrate this so that you can discover the joy of looking at shapes and patterns within nature, and use this knowledge to help your painting.

I hope this book will inspire you to enjoy the wonderful world of water colour flower painting.

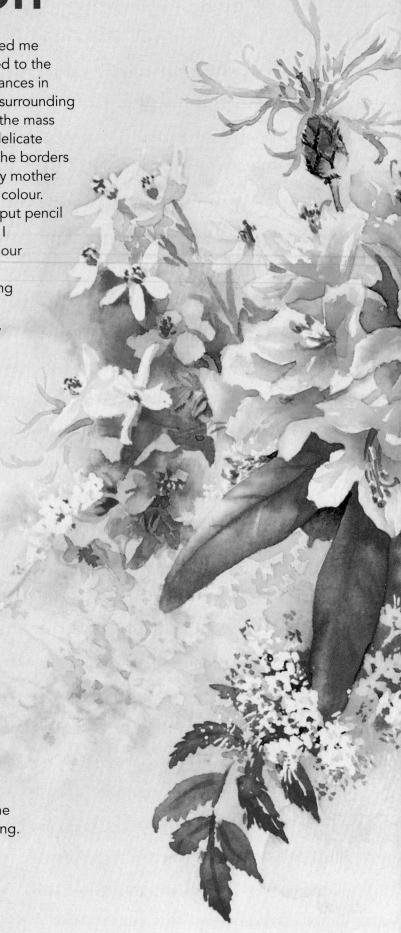

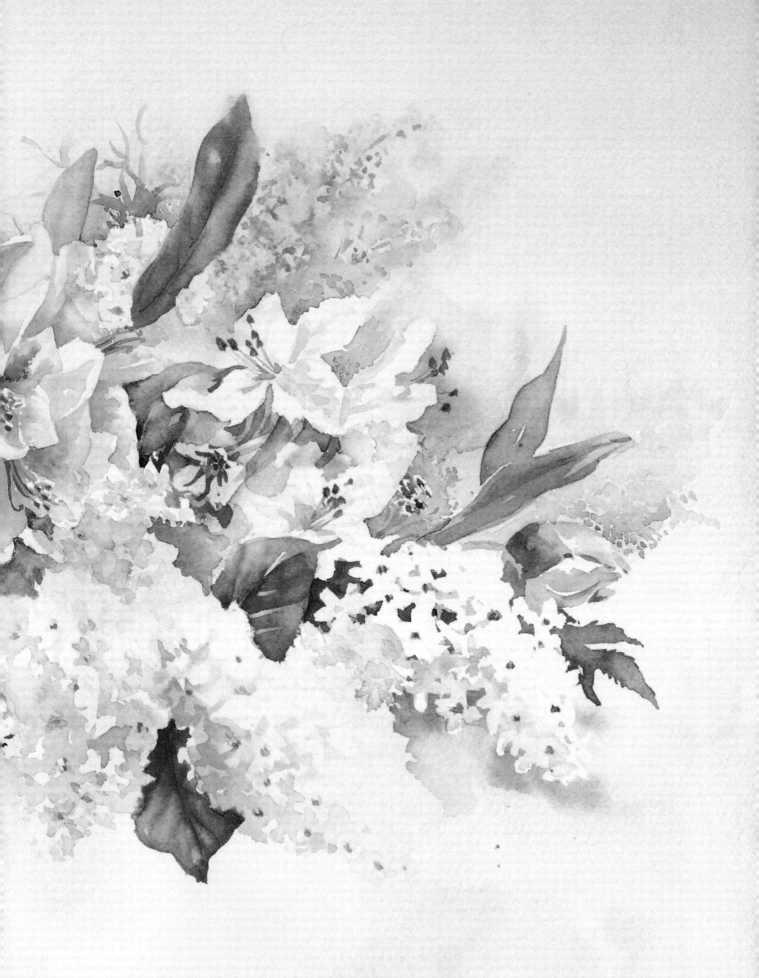

Materials

When you begin water colour flower painting, it is well worth purchasing the best quality materials that you can afford. To keep costs down when starting out, select a small range of materials. You can gradually add to your range as your confidence and ability increase. Buying cheap paints, brushes and paper is false economy and can lead to a discouraging experience. A small range of artists' quality paints will assist you in producing more effective results with colour mixing and application, and good quality brushes enable you to create effective washes and finer detail. You can always improvise on the extra materials.

Water colour paints

Water colour paints are available in students' and artists' quality. I recommend artists' quality as they are permanent and contain a high proportion of good quality finely-ground pigments, whereas students' quality paints are manufactured at a lower price and compromises are therefore made on pigments and manufacturing processes. Due to the intensity of the artists' quality pigments and the purity of colour, less paint is required when mixing. This results in a fresh, flowing appearance when combined with water.

Paints can be purchased in tubes or as solid blocks of compressed colour known as pans, which are available in full or half size, and Winsor & Newton also make large pans. The paint from the tubes is moist and lends itself to larger work, but whether you choose tubes or pans is a matter of personal preference.

I have always used pans as I love their accessibility. As well as using them in the studio, I find them convenient when painting outdoors. The pans can be bought individually or as a set in a rectangular metal or plastic box with a lid that doubles up as a mixing palette. Over the years I have developed a preference for certain colours so I buy them individually and add them to my box. For larger work I like to use full pans which complement the use of larger brushes.

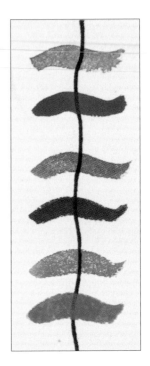

Examples of opaque and transparent colours. From top to bottom: new gamboge, cadmium yellow, alizarin crimson, cadmium red, French ultramarine and cerulean blue.

Opacity and transparency

Transparency is the key characteristic of water colour. As a result of the thinness of a water colour wash, all colours have a transparent quality on paper compared with other media, allowing the reflective white of the paper to shine through. However, some are more transparent than others, and so water colour paints are divided into three groups: transparent, opaque and staining.

Transparent
The white reflective surface of the paper shines through highly transparent colours, giving a fresh, bright appearance. Colours can therefore be glazed on top of each other to create translucent effects.

Opaque
These colours give flatter washes and greater covering over previous washes. When you overwork these colours, the appearance can be dull and lacking in luminosity.

Staining
Certain colours (such as scarlet lake and alizarin crimson) penetrate the paper fibre and cannot be completely removed. If you wish to lift out colour, it is best to avoid these.

Advantages and properties of water colours

Water colours are the perfect medium for expressing the qualities and spirit of a flower. The paint flows beautifully and its translucent properties can be used with subtlety to convey the fragility and delicacy of a flower. Equally, it allows strong, striking use of colour to create vibrant, expressive flowers whilst retaining a jewel-like brilliance and glow.

Depending on the quantity of water used, water colour paints can be controlled within an area, or allowed to run riot to create exciting, spontaneous colour mixes. It is quite unlike any other paint medium such as gouache, acrylic or oil, all of which have creamier opaque consistencies. While gouache and acrylic can be diluted with water, the result is not as translucent as water colour.

Unlike oil, acrylic or pastel where light colours can be applied over dark, water colour washes are built up from light to dark, and highlights and white areas can be created by simply leaving areas of clean paper. Similarly, where white paint needs to be mixed with acrylic, oil and pastel to create a paler tint, simply increasing the amount of water in the water colour mix will tint it.

Water colour is a challenging but exciting medium. Once you have an understanding of the techniques, plenty of practice and perseverance are required, which lead to a very rewarding and therapeutic pastime. Very few materials are required. It is easy and clean to set up and work on the kitchen table, or you can put the materials in a bag and take it on your travels.

Brushes

A brush is the key tool when painting water colour flowers. The size and style of the brush contribute to the essence of a painting because each type and size is designed to create a unique brushstroke. When starting out, I suggest a small range of good quality brushes: sizes 4, 8 and 12 round and a flat half-inch wash brush. I use a wider variety of brushes, depending on the scale of my painting.

I favour a good quality round sable brush. It will hold plenty of paint for washes, retain its spring, and will have a good point for finer detail. As an alternative you can buy excellent nylon or synthetic and sable mix brushes.

Brushes are available in many shapes and sizes, rounds, mops, flats, filberts and riggers.

My brushes

Rigger This was invented for marine painters (they were originally used to paint long straight lines of rigging on ships, hence the name). I use one very occasionally for fine, sweeping lines.

Round I use several sizes depending on the scale of my painting. A size 4 is useful for finer detail, such as stamens and veins, while sizes 7 and 8 are good 'all-rounders'. Sizes 9, 10, 12 and 16 are great for larger details and washes.

Wash brush A 7/8 series 140 squirrel hair wash brush is ideal for wetting paper or applying large areas of colour quickly and evenly.

Flat and **filbert brushes** Flat brushes are versatile: their broad edge can be used to apply base washes or to create bold strokes of varying widths, while the thin edge can be used to make fine lines. Filbert brushes are similar to flats, but the head is oval-shaped, allowing for softer blending.

Experiment with varying brush types to suggest the many shapes and sizes of leaves and petals. When working indoors, I keep my brushes in a container, tips facing upwards.

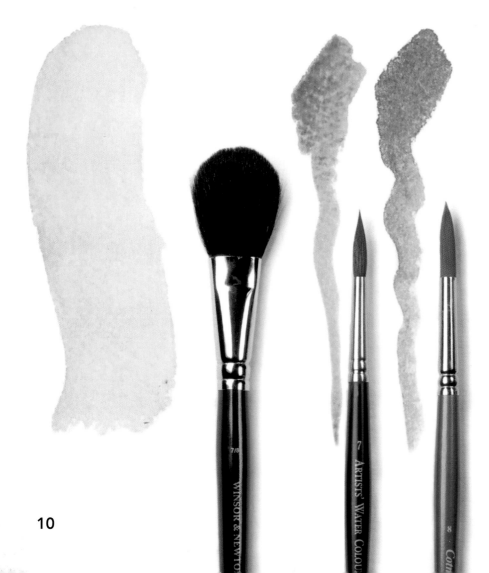

A selection of brushes along with simple brushstrokes. From left to right: 7/8 series 140 squirrel hair wash brush, size 7 Artists' Water Colour Sable round brush, size 8 Cotman III round brush.

10

Cleaning and storage

Well cared for brushes will last a long time. Leaving your brushes tip down in water is a recipe for disaster. The hairs will become bent and damaged. In between using a brush, rinse it, dab it on cloth or kitchen paper to remove excess water and lay it flat or with the tip facing upwards in a container. Always rinse well under a tap when you have completely finished painting.

When transporting my brushes, I use a wallet for protection.

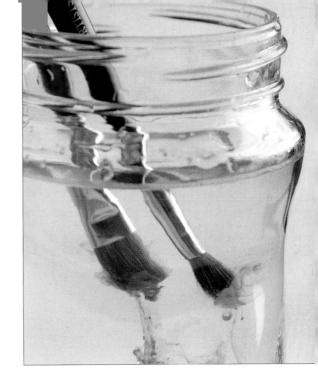

Brushstrokes

The consistency of paint can affect the type of brushstroke made. Too wet a brush can result in losing control of the paint, whilst too dry a brush will require more frequent reloading. This can lead to an overworked, streaky effect.

Plenty of practice is the only way to gauge the consistency and experimentation with the different brushes shown will broaden your techniques in water colour.

A selection of brushes along with the simple flowers they were used to paint. From left to right: size 3 Artists' Water Colour Sable round brush, 10mm/³⁄₈in Artists' Water Colour Sable one-stroke flat brush, size 2 Artists' Water Colour Sable Rigger, size 16 Cotman III round brush.

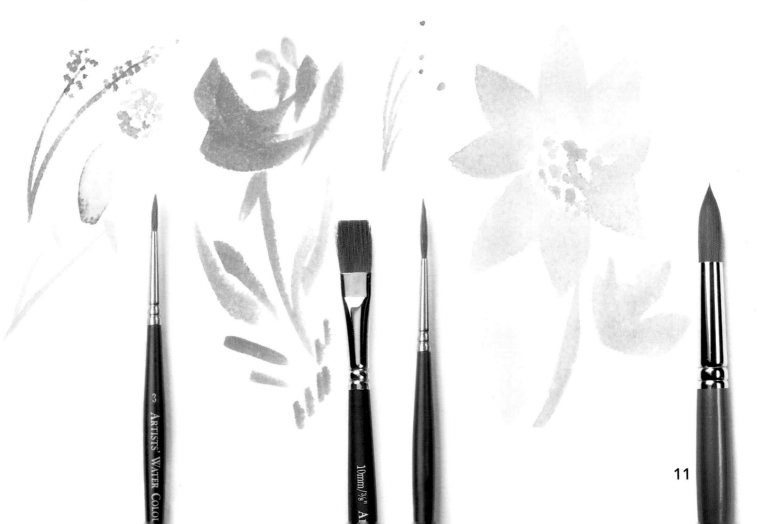

Papers

A wide range of water colour papers is available. It is well worth experimenting with different types and qualities to discover which responds to your method of painting. Initially I suggest you start by using an averagely priced wood pulp paper, which is harder and more forgiving in terms of absorbency than the more expensive cotton rag paper. The quality of the paints and brushes is more important at this stage and you will need plenty of paper to practise and experiment on. I began painting successfully on a wood pulp paper and have now moved on to using cotton rag paper.

Finish

Water colour paper is available in three different surface finishes. When looking at and feeling water colour paper you will notice different textures, namely Rough, Not (cold pressed) and HP (hot pressed). The surface finishes can vary depending on the manufacturer.

Rough This has a rough texture or pronounced 'tooth' as it is often called. When a colour wash is applied, the brush drags over the surface creating a dry brushstroke effect due to paint settling in some dips whilst missing others. The result is a shimmering effect.

Not (cold pressed) This is the most commonly used and versatile paper for most general subjects, one I would certainly recommend for flower painting. It has a semi-rough surface, effective for creating washes and sufficient for detail.

HP (hot pressed) This has a smooth, harder surface suitable for precise, detailed work such as botanical illustration.

Weight

Water colour paper is available in several weights, which refers to the weight of a ream (500 sheets) of a given size. Paper weight is indicated in either pounds per ream (lb) or grams per square metre (gsm).

Thinner paper, such as 190gsm (90lb), is suitable for smaller, more detailed paintings. Unless stretched (see opposite), it tends to buckle if a wash is applied.

Heavier paper, such as 300gsm (140lb), is a more versatile paper suitable for, and popular with, beginners. I generally use this weight. If you wish to work really wet, I suggest using an even heavier paper, such as 600gsm (300lb).

Paper can be purchased by the sheet and cut to size, or alternatively a wide range of pads is available. I enjoy working on a 300gsm (140lb) block pad. The paper remains taut whilst providing a firm surface to work on.

Stretching

This is a simple process. Wet the paper thoroughly, place it on a board, and tape each edge with wet gummed paper, overlapping it by approximately 1cm (½in) on each side.

Left flat to dry naturally, the fibres in the paper contract slightly, resulting in a taut and perfectly smooth surface that will not buckle. Remember to prepare paper well in advance to allow for drying time.

Granulation

Granulation is a characteristic of certain paints that can add visual texture and excitement to a painting. Small granules of pigment float in the wash and settle in the hollows of the paper as the paint dries, giving different effects depending on the paper surface. I have used cerulean blue to illustrate this in the examples below.

The granulation of a pigment is more obvious on a Rough finish paper due to its deep wells, which create a mottled effect.

Granulation is also effective on a Not medium texture paper.

The fine pigment granules are not so obvious on a smooth, HP paper.

Colour

Water colour paper can be purchased in tinted tones which are worth experimenting on.

I prefer to use white or off-white, as this reflects the maximum amount of light back through the transparent washes of colour, lending itself to flower painting.

Other materials

Drawing boards An economical option is to cut a piece of MDF board. It needs to be approximately 5cm (2in) wider than the paper size to allow for stretching if required. I like my board to be at an angle of roughly 15–20 degrees for the paint to flow downwards and remain on the paper without dripping. The advantage of an upright easel is being able to stand back easily to view the picture surface.

A desk easel can be useful for smaller paintings but I find it just as effective to prop my board at an angle against a block of wood.

Palette I tend to mix on my palette lid and use a simple plastic palette for larger washes. Tubes of paint can be kept in a food storage container and the lid can double up as a palette.

Pencils, eraser and sharpener 2B and B pencils produce a soft line and a soft putty eraser is gentle on the paper.

Masking tape If I have not stretched my paper, I loosely tape it on to my board using a low-tack masking tape.

Gummed paper This needs to be approximately 5cm (2in) wide, and is used for stretching paper.

Kitchen towel I am never without this. It absorbs excess water from my brush and when dampened I can quickly clean my palette.

Water containers I recommend using two so one remains clean for re-wetting areas.

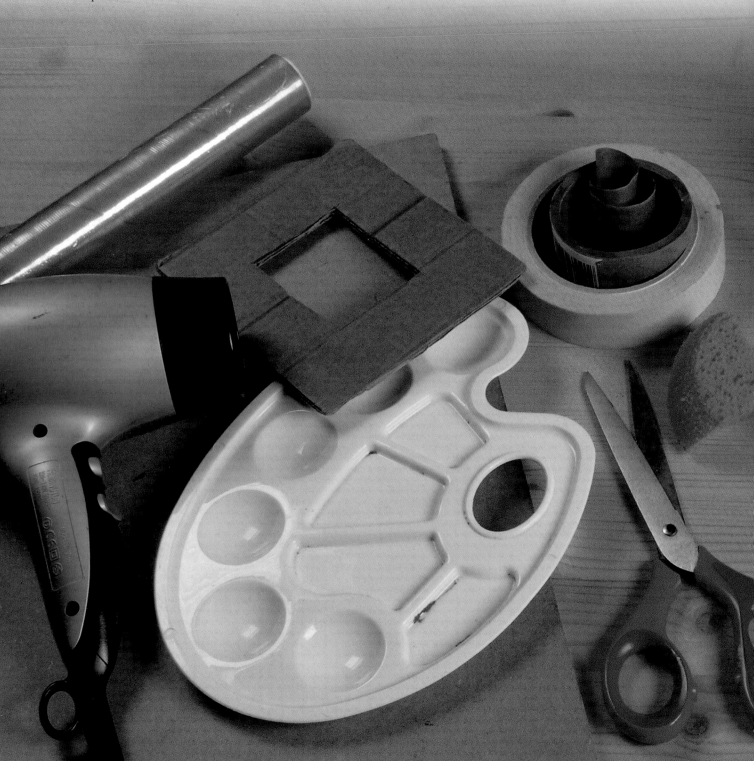

Hairdryer This is useful indoors for speed drying in between washes.

Water dropper A drop or two of water will dilute paint in the palette or moisten a pan of paint before use.

Fine permanent drawing pen 05 This is ideal for quick sketches.

Feather/sharpened stick/toothbrush/sponge These are simple tools for applying masking fluid or paint.

Masking fluid A latex solution which dries when applied to paper to form a resist against washes of paint. It rubs off to reveal white paper when the paint is dry.

Salt and plastic food wrap These are ideal for extra effects.

Scissors A necessary tool to trim paper and cut flowers.

Flower containers and oasis I collect vases in various shapes, sizes and colours, both glass and ceramic to complement my choice of flowers. Oasis can be purchased at a florist, soaked in water and placed on a small dish or saucer. Single flower stems can then be pushed in and held securely at any angle.

Sketchbook I recommend you keep a small sketchbook with you to jot down ideas, record colours and make sketches of flowers.

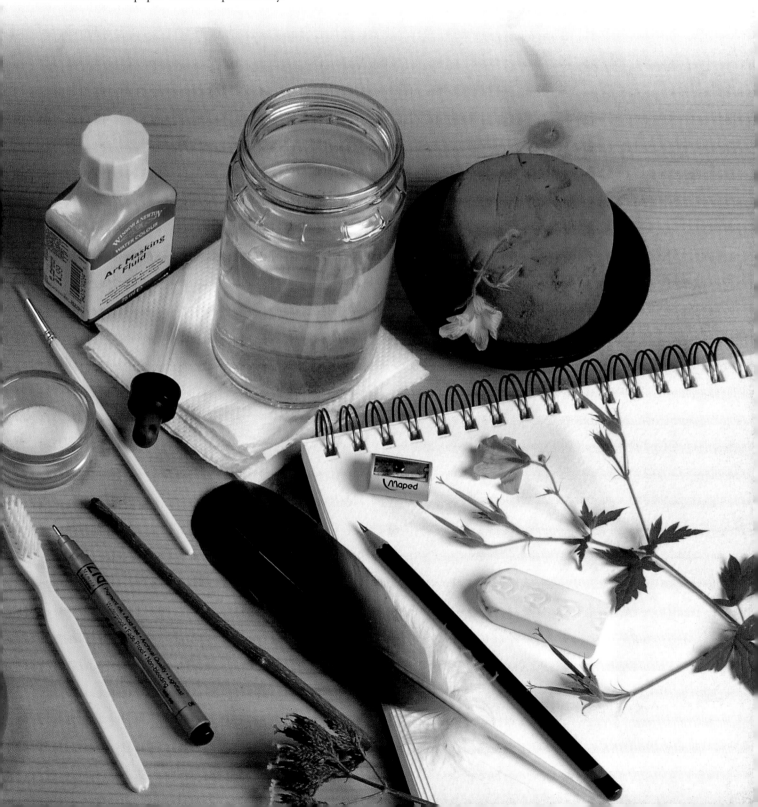

Colour

Colour is one of the most exciting aspects of flower painting. We are drawn to flowers by their many colours – hot reds, vibrant pinks, soft pastels – the colours are endless. Having a basic knowledge and understanding of colour theory and the different ways of applying water colour are the foundation to capturing the individual essence of a flower.

The colour wheel

The next few pages describe the various qualities of colour and how they relate to water colour flower painting.

To the right, you will see a colour wheel in the shape of a flower, demonstrating the basic rules of colour in water colour.

A vast colour range can be created from mixing just three colours, which I have illustrated on the colour wheel.

Primary colours

The primary colours are those that can not be produced from mixtures of any other colours: red, yellow and blue.

The colours created on the colour wheel are the result of the primary-coloured paints I chose: scarlet lake, permanent rose, new gamboge and French ultramarine.

There are many variations of primary shades or hues. You will notice that I have used two different reds. Colours can be described as warm or cool, and each primary has warm and cool variations, so when painting a subject I always analyse its properties in order to select the appropriate primary.

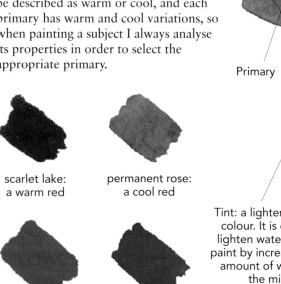

scarlet lake:
a warm red

permanent rose:
a cool red

new gamboge:
a warm yellow

French ultramarine:
a warm blue

Tertiary colours: produced by mixing equal quantities of a primary with the adjacent secondary.

Primary colours: can not be mixed from other colours.

Secondary colours: produced by an equal mix of two primary colours

Primary

Primary

Tint: a lighter tone of colour. It is easy to lighten water colour paint by increasing the amount of water in the mix.

Earth colours and rich shades can be created by combining two complementary colours (see page 18).

Shade: a darker tone of colour. Adding less water to the mix keeps the hue of the paint strong.

In the stem I have built up successive washes of colour to strengthen tone (see page 19).

16

Secondary and tertiary colours

Equal parts of two primary colours mixed together create a secondary colour – red and yellow make orange, yellow and blue make green and blue and red make purple. This is illustrated in the chart to the right.

The primary paints you choose should be appropriate to the secondary you wish to mix. For example, if the subject I am painting is a vibrant orange, I choose a hot red such as scarlet lake and combine it with yellow, but when selecting a red to produce a clean, fresh, purple I choose a cooler shade such as permanent rose to mix with a blue. The chart below illustrates this.

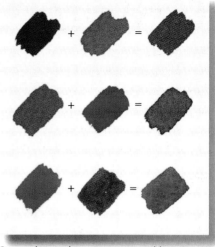

Secondary colours are created by mixing two primary colours.

Warm primary Cool primary

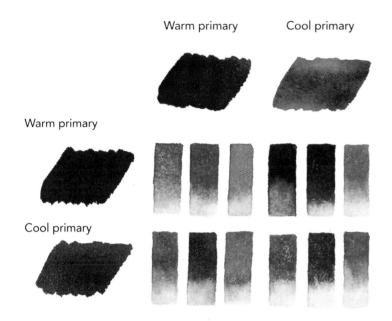

Warm primary

Cool primary

Two primary reds (one warm, one cool) mixed in various quantities with warm and cool blues.

You will notice that the secondary purples created using the cooler permanent rose are far fresher than those mixed with scarlet lake. The shades of purple created can also vary from cool to warm depending on the proportions of the primary colours used. The same applies when mixing greens and oranges.

Mixing equal amounts of a primary colour with the secondary next to it results in the tertiary colours.

Hue and colour relationships

The colours opposite one another on the colour wheel are called complementary pairs. These are: red and green, yellow and purple, and blue and orange.

Placed side by side, they create a wonderful contrast and intensify one another. Imagine a red flower surrounded by green foliage: the intensity of the red appears to be magnified. Colours next to one another on the colour wheel (blue and purple for example) harmonise, but when used on their own in a painting, may appear rather cool and dull. A touch of a complementary orange or yellow will bring it to life.

When selecting flowers to paint, or when considering a background colour to use, I always think of the complementary colour. If you refer to the detail (right) you will see that the touches of purple in the background harmonise with the central flower, while the complementary yellow enhances and gives it a lift.

Another advantage of having some understanding of complementary colours is the awareness that these pairs neutralise each other's intensity when mixed together or glazed one on top of the other. This results in shades and earthy colours. To illustrate this I have applied a light wash on the tip of each primary and secondary colour on the colour wheel with its opposite colour.

Looking at the colour circle you will see that the hotter reds, oranges and yellows come forward and the blues and purples recede. Bear this in mind when you are painting to give the illusion of depth and recession.

Within the stem and leaf of the colour wheel I have illustrated examples of tone. Tone describes a colour's relative lightness or darkness and can be used to describe a tint or shade. I have added water to a colour to make a tint and have built up successive washes of colour to illustrate increasing tones.

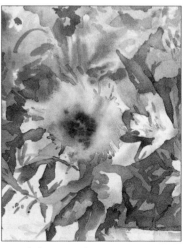

Detail showing the interaction between the complementary colours yellow and purple.

Earth colours

Earth colours can be created by mixing the tertiary colours (see pages 16–17) together. Rather than use ready-made earth colours, I use rich, fresh, earthy hues by mixing a strong pigment of each tertiary colour with its neighbour on the colour circle (see the table below).

However, applying a wash of one tertiary colour over a wet base of another tertiary colour creates an even richer appearance due to the mottled effect of the two colours combining, as shown to the right. The wet-into-wet technique is demonstrated in more depth on page 27.

Tertiary mauve with
tertiary orange

Tertiary green with
tertiary mauve

Tertiary orange with
tertiary green

Tertiary green with
tertiary mauve

Tertiary mauve with
tertiary orange

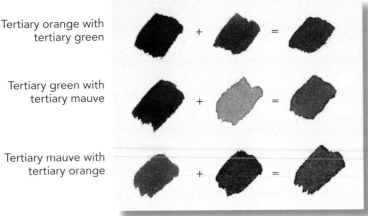

Tertiary orange with
tertiary green

Mixing complementary colours

Combining complementary colours on the colour wheel will also produce neutral earthy shades. I find having the knowledge of complementary mixing very important. If I am painting a red flower and I wish to make the red less intense or to create its shadow colour, I add a touch of its complementary green.

Greys can also be produced this way. Observe a white flower: the greys are not dull, they may appear to be a green-grey, pink-grey or blue-grey.

The complementary mixing chart illustrates the warm colours, red, orange and yellow which appear on one side of the colour circle with the cool shades, green, blue and mauve on the opposite side. Colour band 1 illustrates how a tiny touch of the cool colour opposite (e.g. mainly red with a touch of green) tones down and makes its colour less intense.

Colour band 2 shows equal parts of a warm and cool colour combined to create neutral earth tones, while colour band 3 shows how a touch of a warm colour added to a cool tone (e.g. mostly green with a touch of red) neutralises it, creating greyish tones which are ideal when diluted to suggest shadows on white flowers.

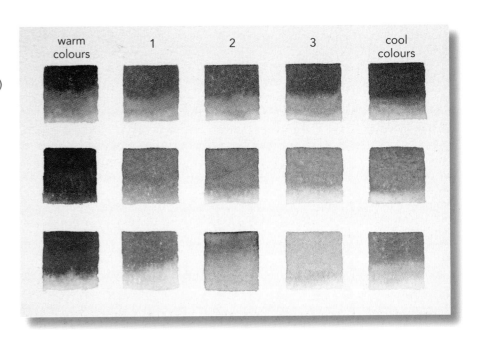

warm colours · 1 · 2 · 3 · cool colours

Keeping paint clean

When colour mixing, I use a combination of two colours as a rule, and very occasionally mix a third if I need to tone down a colour. Colours lose their vibrancy and become dull and muddy if mixed from too many pigments.

It is also essential to regularly rinse or sponge-wash your palette, so other shades are not picked up on your brush. Replenish water frequently as muddy water results in a dull painting, which will not reflect the freshness of a flower.

Tone

Tone refers to the lightness or darkness of a colour. Every colour has a wide range of tones. The tone of a water colour can be altered by adding water to the mix: the more water you add the paler the tone becomes.

You can also build up successive washes of colour to increase the strength of tone. In the example below I have illustrated an example of building up successive washes of colour to create three tones varying from light to dark.

Tip

Keeping your paints clean and organised in your palette is essential.

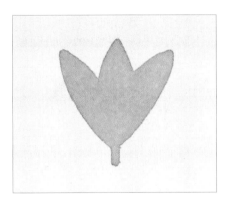 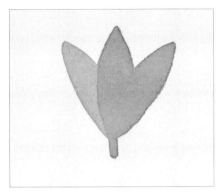 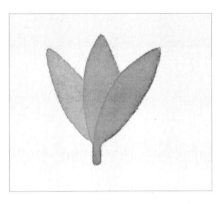

1 Mix a watery pool of colour, then apply the first wash over the entire area and leave to dry.

2 Using the same pool of colour apply a second wash to the second and third petals. Allow to dry.

3 Apply a third wash to the final petal and allow it to dry.

Here are further examples of flowers built up in the same way.

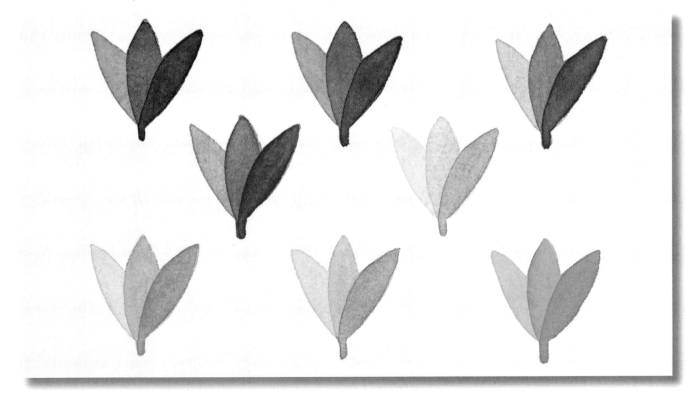

Greens

Greens are the basis of nature. It is a balancing colour connecting the contrasting electric (blue) and magnetic (red) flower shades. We are surrounded by numerous shades of green and in my experience the mixing of correct shades can be a cause of frustration for a flower painting student. Often more time is spent mixing brightly coloured flower shades, but greens can be just as fascinating. The shades of green in nature vary according to the time of year and the time of day due to the light and shade.

Ready-made greens are not necessary in a palette, as all greens can be mixed by combining blues and yellows. I have only sap green in my palette, which I rarely use on its own due to its rather bright and synthetic appearance, but instead add a little to a green I have already mixed to liven it up.

Here I have illustrated a chart showing the numerous greens I can achieve by mixing all the yellows and blues in my palette. Regardless of what shades of yellow and blue your palette consists, I suggest you make your own chart so that you can instantly refer to it. Place each colour in order of its warmth, except for indigo which I have placed at the bottom of the chart. This is because although it is a cool blue, it produces the richest shades of green.

Using cerulean blue and aureolin yellow as an example, you will see that leaf 1 is produced by using proportionally more yellow to blue, the central leaf 2 is an equal combination of the two colours and leaf 3 contains a larger proportion of blue. The results of the three mixes are quite different, owing to the differing proportions of each colour.

		Aureolin	New gamboge	Indian yellow	Raw sienna

Cerulean blue — The greens produced using cerulean blue have a granular textured effect.

Winsor blue (green shade) — Winsor blue (green shade) makes fresh clean greens when combined with different yellows.

Cobalt blue — A cool blue which creates fresh mixes.

French ultramarine — Slightly warmer and deeper than cobalt blue, French ultramarine gives more warmth and depth to the greens when combined with yellows.

Indigo — Indigo gives added depth when mixed with yellow, ideal for mixing deep shades of green. Payne's gray is a good alternative.

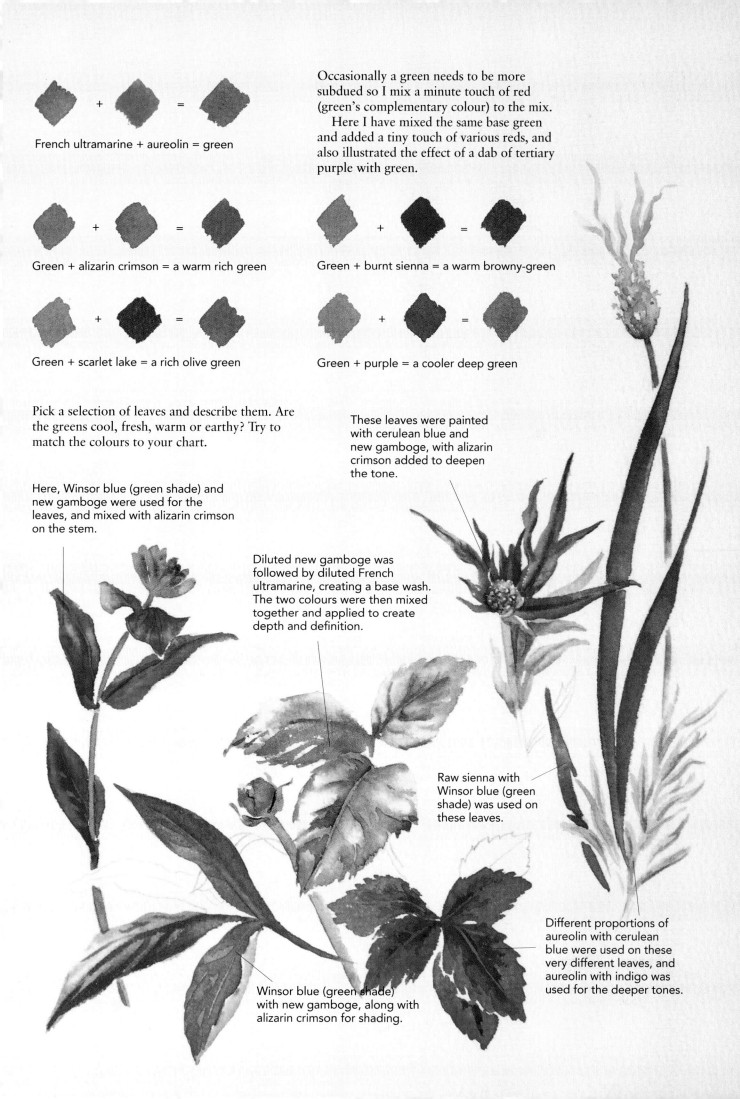

French ultramarine + aureolin = green

Green + alizarin crimson = a warm rich green

Green + scarlet lake = a rich olive green

Green + burnt sienna = a warm browny-green

Green + purple = a cooler deep green

Occasionally a green needs to be more subdued so I mix a minute touch of red (green's complementary colour) to the mix.

Here I have mixed the same base green and added a tiny touch of various reds, and also illustrated the effect of a dab of tertiary purple with green.

Pick a selection of leaves and describe them. Are the greens cool, fresh, warm or earthy? Try to match the colours to your chart.

These leaves were painted with cerulean blue and new gamboge, with alizarin crimson added to deepen the tone.

Here, Winsor blue (green shade) and new gamboge were used for the leaves, and mixed with alizarin crimson on the stem.

Diluted new gamboge was followed by diluted French ultramarine, creating a base wash. The two colours were then mixed together and applied to create depth and definition.

Raw sienna with Winsor blue (green shade) was used on these leaves.

Different proportions of aureolin with cerulean blue were used on these very different leaves, and aureolin with indigo was used for the deeper tones.

Winsor blue (green shade) with new gamboge, along with alizarin crimson for shading.

Laying out your palette

These are the colours I enjoy working with. When mixing colour I consider whether I want to create a warm or cool hue; whether I require a granulating colour (see page 13) to give texture, or a transparent colour with which to glaze; and numerous other decisions.

 I use a palette of sixteen colours, revolving around the three primary colours and have a range of up to five different shades per colour. I favour mainly transparent colours due to their translucent properties which result in paintings which are fresh and bright.

Yellows

All the yellows I use are transparent colours and range from cool to warm. The choice of yellow is particularly important when mixing greens as indicated in the green colour chart, page 20.

Aureolin Cool, transparent and semi-staining. This is the coolest yellow I use. It has a greenish tinge and lends itself to fresh spring green shades.

It is a good alternative to lemon yellow, which is similar but opaque.

New gamboge Warm, semi-transparent and permanent, this is a good all-rounder which I use frequently. The colour dilutes well to create a bright, fresh appearance.

Indian yellow Very warm, transparent and permanent, Indian yellow is a beautiful strong yellow.

It dilutes and flows well and is ideal to use as a tinted wash background on white paper.

Raw sienna Warm, transparent and extremely permanent. It granulates to give a slightly textured appearance when required.

Tip
Yellow ochre is an opaque version of raw sienna. I favour the latter due to its transparent quality.

Blues

I have a range of five blues ranging from cool to warm. They are mostly transparent except for cerulean blue, which is more opaque and granular, and indigo blue which is opaque.

Cerulean blue Cool, semi-opaque, granular and permanent. I love the effect of texture created by its granular quality as it separates from any colour it is mixed with.

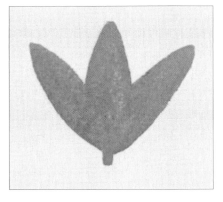

Winsor blue (green shade) Cool, transparent, permanent and staining. I use this as an alternative to cerulean blue as this does not granulate but produces a clean, flowing wash.

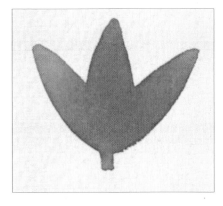

Cobalt blue Cool, semi-transparent, permanent and granular. A blue I frequently use. It produces beautiful fresh shades whatever it is combined with.

Tip
When combined with a tiny amount of another colour, French ultramarine will flow more freely.

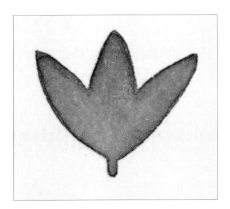

Indigo Cool, opaque and staining. I use this to add depth to colours, but I use it with caution due to its tonal strength, opacity and staining properties.

French ultramarine Warm, transparent, granulating and permanent. A rich blue giving warmth and depth to any colours it is mixed with. It separates and gives a textured appearance.

Reds

I have a palette of five reds ranging from a cool purpley-pink through to a hot yellow-red. Due to a predominance of pink and red flowers, a varied range is required. Fresh pinky-reds can not be mixed from a primary red, so ready-mixed pinks are a necessity for a flower painter.

Quinacridone magenta Cool, transparent and permanent, this is a perfect colour for flower painting. It is a clean, fresh and translucent colour. Mixing permanent rose and cobalt blue is an alternative but not as pure looking.

Permanent rose Cool, transparent, permanent and staining, this is a must for a flower painter, as it is pure and vibrant, perfect for mixing fresh violets and mauves.

Alizarin crimson Cool, transparent moderately permanent and staining. A rich, deep, cool red which I use only occasionally as it can appear too heavy and cannot be lifted due to its staining properties. I like to use a tiny touch of it to give a little depth when mixed with green.

Winsor red Warm, semi-transparent, permanent and staining. I rarely use this on its own as it has a slightly opaque and heavy feel to it. I prefer to paint a base wash of yellow followed by winsor red when it is still wet to give a fresher, more fluid appearance.

Scarlet lake Warm, semi-transparent, permanent and staining. My most frequently used red has a strong, glowing, orangey appearance. When diluted it flows well, and the brightness of scarlet lake can be enhanced by combining it whilst wet with cooler shades of red. This creates a wonderful contrast.

Other colours

I also include a couple of extra colours in my palette, one brown and one green.

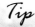

Tip

Equal parts of burnt sienna combined with cobalt blue create a useful grey shade. Due to burnt sienna's transparency, the result is fresh.

Burnt sienna Warm, transparent and permanent. A lovely rich red-brown shade. This can be used as a base for different shades. Blue can be added to produce a cooler, deeper shade.

Permanent sap green Warm, transparent, permanent and staining. It appears rather a bright, synthetic green. I tend to use it combined with other green mixes to freshen them up.

Tip

When starting out on water colour, I recommend that you get to know the colours in your palette by making a chart illustrating each one, labelled with its name. Group each colour from cool to warm and you will soon learn to identify the different shades. Remembering their names and the properties of each colour makes painting more fun.

Pink Peony
31.5 x 19cm (12½ x 7½in)
The fresh pinks of this delicate peony are enhanced by the fresh, complementary greens in the background.

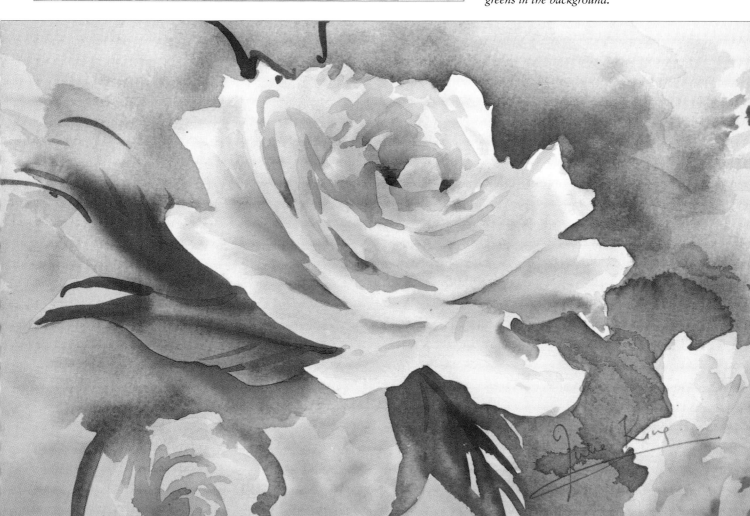

Basic techniques

Although water colour is a wonderful medium for self-expression, being aware of the basic techniques is essential for successful results.

Prepare yourself with plenty of paper and just practise! Through experimentation you will develop your skill for mixing and applying paint. Before you begin, tilt your board and paper at a slight angle so the paint flows very gently downwards.

Preparing paint

Consider the strength of colour you will need and add the water accordingly with either a brush or water dropper. Whatever the size of wash required, whether it is for a large background area or a small petal, always mix a larger pool of colour than you think you will need, as stopping to mix colour in the middle of applying a wash can lead to disaster. Water colour paint dries a lot lighter than it initially appears when wet so always allow for this by mixing a slightly stronger colour than required.

Tip
Before painting, test the strength of colour on a scrap of paper.

1 Wet your brush thoroughly in clean water, then rub the brush over the paint pan to pick up the colour.

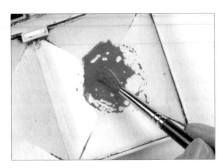

2 Transfer the paint to a mixing well, then repeat until you have a sufficient amount of strong paint.

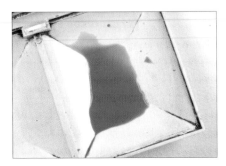

3 Use the brush or a water dropper to transfer clean water to the palette to dilute the paint to the strength required. The consistency will depend on what you are painting.

Flat wash in a shape

A flat wash is the most fundamental technique in water colour. The brush needs to be loaded with plenty of water; however, if it is overloaded, the wash can run out of control. If it is too dry, the wash will appear uneven. Each brushstroke needs to be applied decisively, overlapping the previous one very slightly. The bigger the brush, the fewer brushstrokes will be required. Avoid working back into the wash as it will cause visible streaks and watermarks. This demonstration shows you how to apply a flat wash within a petal shape.

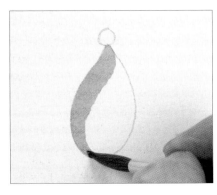

1 Starting from the upper left part of the shape, paint a broad downward stroke, following the curve of the outer edge.

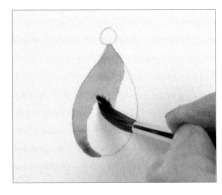

2 Overlap a second brushstroke. Press the brush towards the paper to give more width and to pick up paint from the previous stroke.

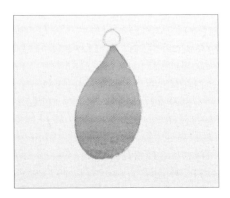

3 Continue, slightly overlapping strokes until the area has been covered. Reload your brush if and when necessary.

Gradated wash – wet-on-dry

I frequently use this technique to suggest varied tone within a shape or background or purely to soften hard edges of colour. It is quite a controlled method for diffusion providing the brush is not overloaded with water. The paint can be applied in a similar way to the basic wash and is diffused on the paper with each successive brushstroke of water. Use a fresh jar of water to diffuse the paint so as to enable the colour to fade completely into the white paper.

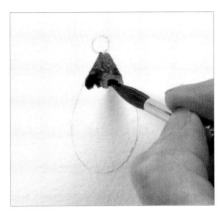 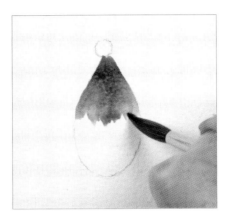 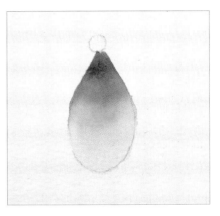

1 Using a fairly strong mix of colour, paint the top section of this shape following the flat wash method.

2 Quickly rinse your brush in clean water. Tap off the excess water and use the damp brush to pull the colour downwards, creating a lighter band of colour.

3 Repeat the process until the colour has completely faded into the white of the paper, creating a gentle gradient of tone.

Gradated wash – wet-into-wet

Pre-wetting the paper before applying paint can help to create a beautiful soft variation of tone. The paint flows with ease on the wet surface and needs to be gently encouraged to diffuse using a minimal number of brushstrokes. Once the sheen of the paper has gone, avoid retouching as this will result in a water-marked effect, called a backrun. Backruns occur when the brush contains more water than the paper, which results in paint which is not thoroughly dry being pushed aside by the excess water and forming a ring.

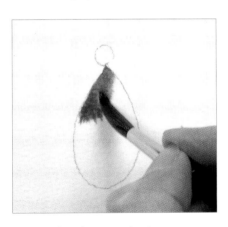 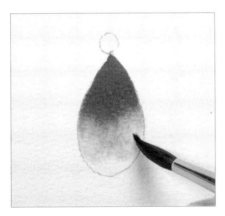 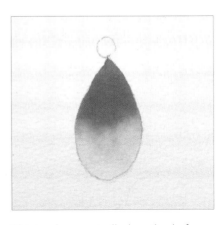

1 Wet the shape with clean water until a sheen develops. Using more pigment in the mix than when painting wet-on-dry, paint the colour into the top of the shape.

2 Quickly clean your brush and remove excess water by tapping the brush over your water pot. Use your damp brush to encourage the paint to bleed into the rest of the shape.

This is a less controlled method of painting than wet-on-dry, that can nevertheless produce beautiful results.

Dry brush

This technique is useful to create texture and detail on leaves or petal shapes. The brush needs to be grazed over a dry surface. For the best results use a Rough or cold-pressed (Not) water colour paper and use quite a dry consistency of paint.

1 Load your brush and remove excess paint on some scrap paper.

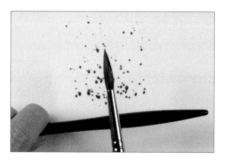

2 Use the side of your brush with very light, controlled brushstrokes to reveal the texture of the water colour paper.

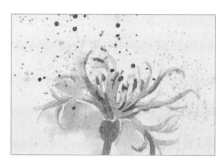

Here is an example of the dry brush technique painted over a dry wash background. The tip of the brush was used to add modelling to the flower.

Spattering

This can evoke a lively atmosphere. The direction of the spatter depends on the way the brush is held and tapped and the size depends on the distance it is held from the paper and the consistency of the paint. Experiment!

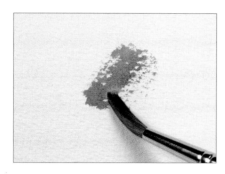

1 Hold a clean brush parallel to, and a little above, the paper.

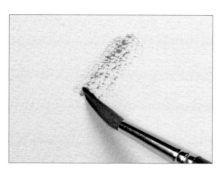

2 Load a second brush with a dilute mix of paint and repeatedly tap it on the first brush as shown to flick spots of paint on to the paper.

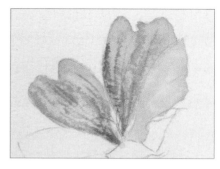

This technique adds texture and drama to your paintings. It can bring a flower to life and suggest movement.

Lifting out

An effective method of producing highlights. Avoid lifting out immediately after applying the paint. For the best effect, leave for a few moments and then sweep your brush through the paint. A synthetic brush is slightly firmer for this purpose.

1 Paint your petal as normal, using the wet-on-dry technique, and let it dry for a few moments.

2 Wet a synthetic brush and remove excess water, then draw the tip of the brush across the damp paint to lift off pigment as shown.

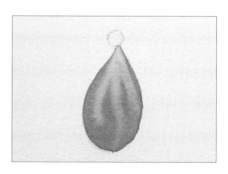

3 Repeat as required to build up texture in the petal.

Overlaying glazes

When glazing, one thin wash is applied over another. I favour using transparent colours for this method as the white reflective surface of the paper shines through and each successive glaze of colour remains fresh. Make sure each wash is thoroughly dry before applying the next, otherwise the results will be muddy.

Avoid too many washes. More than three or four will result in a heavier, opaque look. Detail such as veins can be applied between washes. In the example below I have re-wet the surface with clean water after each glaze, but this method also works using the wet-on-dry approach.

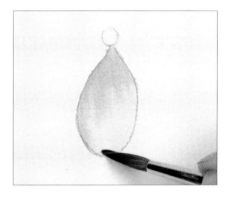

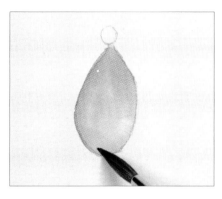

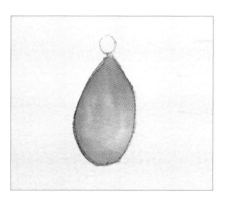

1 Wet the surface and paint your petal with the first colour (in this case, new gamboge). Allow the paint to dry completely.

2 Wet the petal with clean water, then use a thin wash of the second colour (permanent rose) to cover areas at the edges. Allow to dry.

Further layers of glazing will enhance the translucent effect, but more than three or four can become heavy and opaque.

Dropping in

This example shows a wet-into-wet method of producing a variegated colour effect in a background (i.e. negative painting), but it works equally well for positive shapes such as leaves and petals.

Work quickly and confidently, allowing the colour to spread as you work. In larger areas, try tilting your work slightly so that the colours will blend together while wet. Avoid overusing the brush and retouching areas that have started to dry to help prevent an overworked, streaky and water-marked effect.

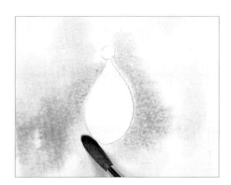

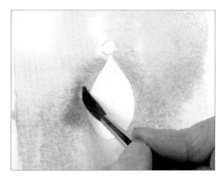

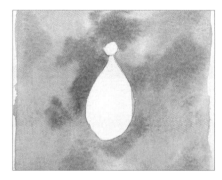

1 Wet the whole area of background with either water or a pale wash of colour, being careful not to go over the lines of the drawing. Use a brush loaded with a dilute wash to paint fairly random areas of colour (a variegated wash) into the water.

2 While the area is still wet, drop in areas of a second dilute colour and allow them to bleed and blend together.

3 As long as the area remains wet, you can add further colours. Allow to dry thoroughly once you have finished.

Using salt

As salt dissolves, it absorbs the wet paint. This creates a textured effect useful for adding interest to a background or for suggesting tiny flower heads. Either plain table salt or the coarser type can be used.

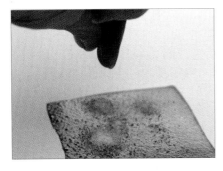

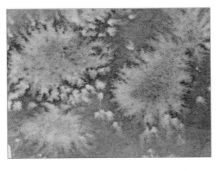

1 Drop a pinch of salt on to a wet wash and allow to dissolve into the paint. When dry, brush the excess salt away.

If dropped on to very wet paint, the effect is fairly diffuse.

If the paper is merely damp, the effect is very different.

Using masking fluid

Masking fluid is particularly useful if you wish to retain areas of white paper because it acts as a resist to the paint, keeping the paper clean.

Tip
Rinse your brush in water with a tiny amount of washing up liquid added to it before and immediately after applying masking fluid to the paper. This helps to protect the brush.

1 Using an old brush, twig or quill of a feather, apply the masking fluid to the paper and allow to dry.

2 Apply a wash of colour over the top and allow to dry.

3 Use a clean eraser or the tip of your finger to gently rub the masking fluid away, revealing the unmarked paper.

Using plastic food wrap

When applied to wet paint, this produces an exciting texture, ideal for conveying certain leaves and petals.
Apply the paint fairly quickly and randomly, as once the paint is dry the plastic will not adhere to it.

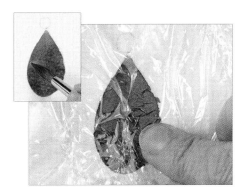 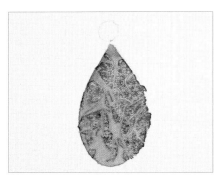 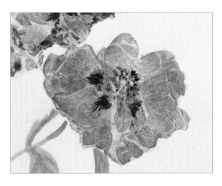

1 Lay a wet wash into the petal (see inset), then crumple some plastic food wrap tightly. Unravel it, and gently lower it on to the wet paint. Gently press down to create a creased effect.

2 Allow to dry thoroughly and then carefully remove the plastic food wrap.

This technique is perfect for evoking the delicate textures on leaves and petals.

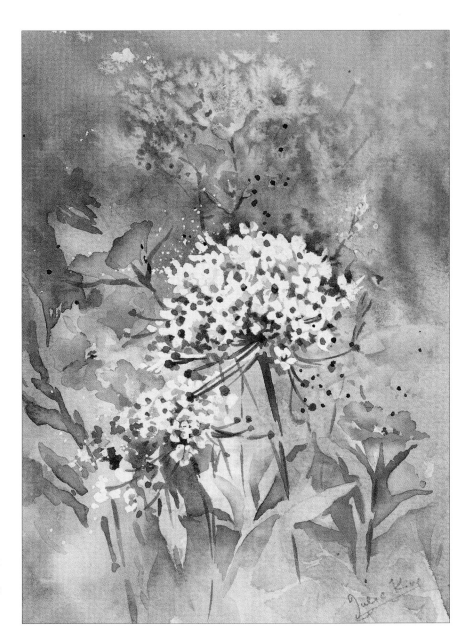

Meadow Flowers
16 x 21cm (6¼ x 8¼in)

This picture combines some of the techniques demonstrated in this chapter.

Negative painting

I often use what is termed as a 'negative' approach to painting, that is to say I look at the background as being equally important as the subject I am going to paint. Our eyes immediately recognise a 'positive' object as a definite shape: for example, a flower appears to be in the foreground and the area surrounding it, known as the 'negative space', is behind. Both positive and negative shapes combine to make the whole as they both share the same edges.

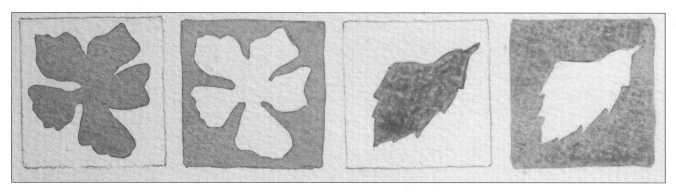

Positive shape in pink Negative shape in pink Positive shape in blue Negative shape in blue

Negative painting exercise

This exercise will show you how useful negative painting can be when painting flowers in water colour.

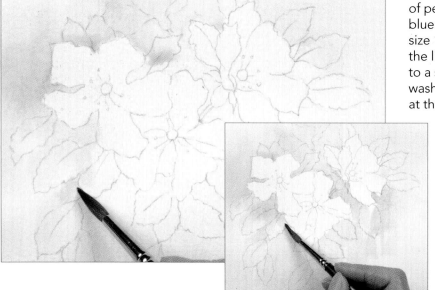

1 With your image in place, prepare pools of permanent rose, aureolin and cobalt blue. Wet the background area using a size 10 brush, being careful not to go over the lines of the main three flowers. Switch to a size 7 brush and drop in a very thin wash of permanent rose near the flowers at the top.

2 Clean your brush and add aureolin wet-into-wet in patches around the middle and bottom of the picture.

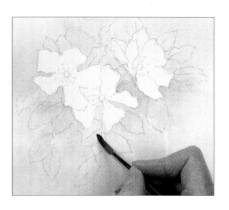

3 Repeat the process with cobalt blue, allowing it to bleed into the yellow to create greens.

4 Make a green mix of aureolin with a little cobalt blue, and apply wet-into-wet around the flowers. Allow to dry.

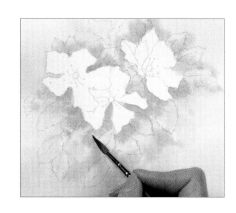

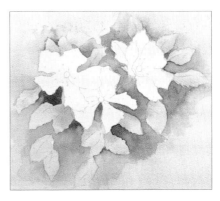

5 Using a slightly stronger (i.e. less dilute) green mix, apply the colour in the negative areas between the leaves and the flowers in preparation for a wet-on-dry diffused effect.

6 Rinse your brush, tap away excess water into your pot, then diffuse the strong green tone with your wet brush, enabling the colour to fade into the original background wash.

7 Continue working around the background foliage in this way, keeping the tone stronger towards the centre and around the flowers, and lighter towards the edges.

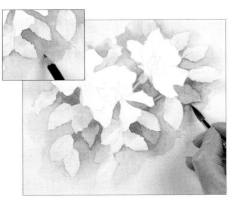

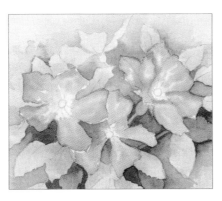

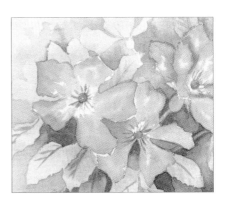

8 When dry, sketch in some additional background leaves with a pencil (see inset), then surround these leaf shapes with a strong diffused green mix as shown, suggesting depth within the foliage.

9 Use a stronger tone of permanent rose to paint round the negative area of the top flower, then diffuse it outwards. Suggest further flowers in the top left in the same way, and use a stronger mix to colour the positive petals of the main flowers wet-into-wet. Allow the painting to dry thoroughly.

10 Use stronger tones of the green and pink mixes with the tip of the brush to add detailing to the foreground leaves and flowers. Use the green to add the centres to the flowers and for the stamens.

Tip
In nature, no leaves are exactly the same colour due to the effects of light and shade, so feel free to vary the green hues by adding more yellow or blue.

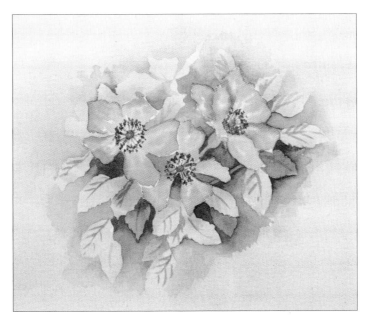

11 Complete the stamens with stippled dots of aureolin yellow mixed with permanent rose, overlaid with purple dots made from a mix of permanent rose and cobalt blue. Allow to dry.

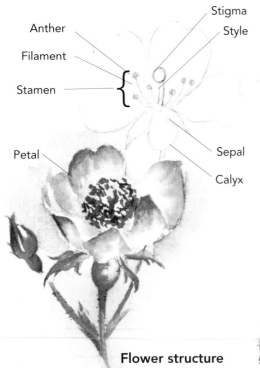

Anther

Stigma

Style

Filament

Stamen

Petal

Sepal

Calyx

Flower structure

Flower shapes and structure

Understanding the general structure of a flower is very important. Although I am not a botanical flower painter, I find it useful to be aware of the terms used for flower parts. If you pick a selection of flowers, you will notice the similarities in shape and construction and it is well worth studying their structure before making a drawing. Observe their amazing centres, how the flower heads are joined to their stems, and how many petals each has. You will be amazed at their intricacy and sheer beauty.

Look at the basic shapes of flowers. They can almost always be categorised into geometric forms, which assist when drawing them. I very often commence a drawing by using a 2B pencil very lightly to indicate its simplest geometric shape, followed by more detail. I then gently remove the geometric pencil sketch with a soft eraser.

Rays

Sunflower, daisy, rudbeckia

Many flowers are based on the simple circle or ellipse. When viewing a rudbeckia from above or straight on, commence by drawing a light circle to suggest the approximate edge of the petals and an inner circle for the centre of the flower. Gradually tilt the flower and you will observe how its shape becomes elliptical.

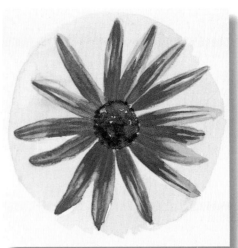

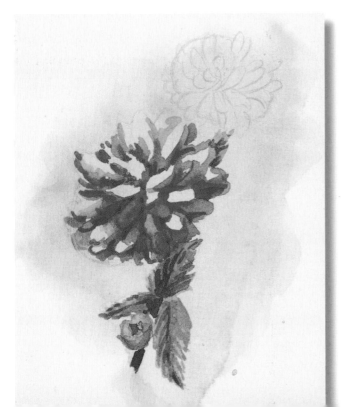

Pompoms

Chrysanthemum, kerria, carnation

Like ray-shaped flowers, pompom-shaped flowers are based on a circle or ellipse.

All the petals in these flowers radiate from the central point, where the calyx meets the petal, creating evenly placed petals within a circular or spherical shape.

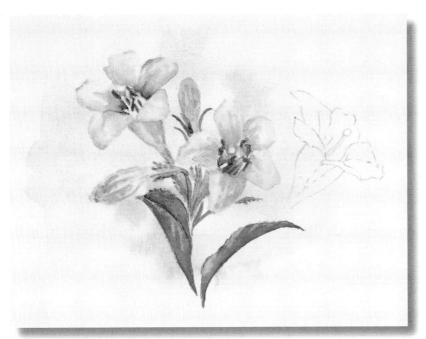

Trumpets

Weigela, hibiscus, lily

These flowers are based on a cylindrical shape, which tapers into an ellipse when viewed from the side. There is a flowing central line from the base of the tube (calyx) to the outer point of each petal.

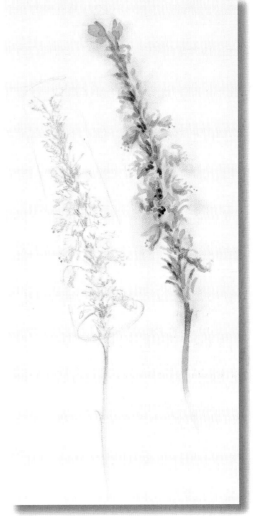

Spikes

Lilac, lavender, delphinium

An arrangement of flowers, small or large, attached at the base to a long stem. View the shape as a cylinder or a cone tapering in towards the top. The flowers can then be suggested directly with paint on a small scale spike, as in this example, or with light circles or ellipses in the case of a larger flower head.

Multiheaded

Hydrangea, phlox, primula

These flowers are made up of smaller flower heads. View this flower as a whole by sketching a large circle or ellipse followed by smaller ones within.

Cup and bowl

Poppy, rose

Many flowers fall into this category. Roses and poppies tend to unfurl to suggest a beautiful bowl shape.

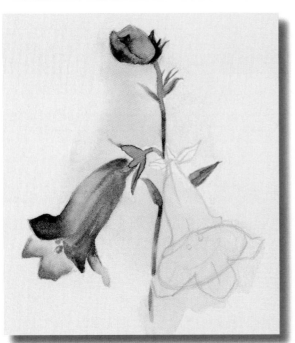

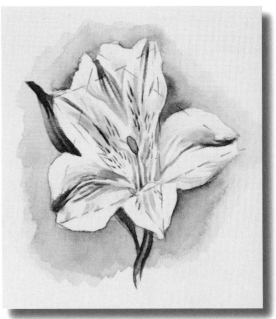

Star shape

Alstroemeria, daffodil

In their simplest form these appear to be constructed as two triangles, one overlapping the other, with three similar petals above and three beneath.

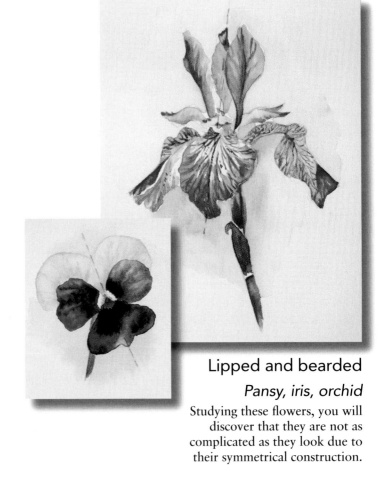

Bells

Penstemon, bluebell, campanula

Commence by drawing a tubular structure and elliptical shape. This makes it easier to plot the petals, which curl back slightly. Using deeper tones within the tube can help to emphasise the contrast against the lighter petals.

Lipped and bearded

Pansy, iris, orchid

Studying these flowers, you will discover that they are not as complicated as they look due to their symmetrical construction.

Leaves and their structure

Leaves are as varied as flowers, ranging in colour, size, shape and growth pattern. Select a number of flowers and observe the different leaf placements on the stem. Leaves are arranged on the stem to receive the maximum amount of solar energy to keep the plant growing. You will discover that each leaf is placed where it will receive light without shading the one below.

Leaves can be as simple as a single blade or quite intricate and frilly. The edges can be very varied too, from the smooth edge of a camellia leaf to the serrated edge of a rose leaf.

When drawing leaves, lightly pencil the central vein in first. This is the key to perfecting the shape of a curved leaf. It should be a continuous line following through the upper surface to the lower surface. The outer edges and veins can then be drawn.

Leaf structure

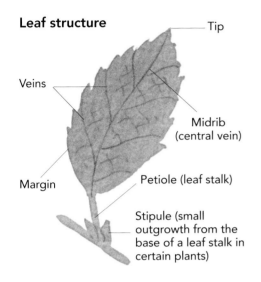

Tip

Veins

Midrib (central vein)

Margin

Petiole (leaf stalk)

Stipule (small outgrowth from the base of a leaf stalk in certain plants)

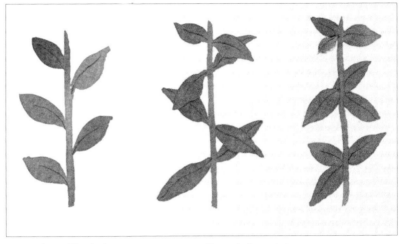

Examples of leaf placement on stems. From left to right: alternate, opposite and whorled.

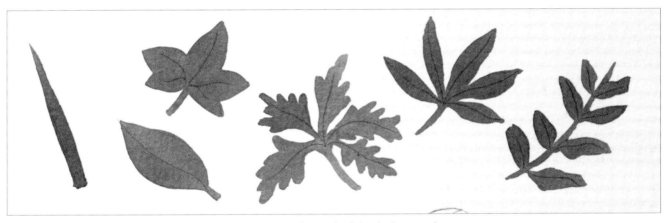

Examples of leaf forms. From left to right: sword-shaped, simple, lobed, dissected, palmate and pinnate.

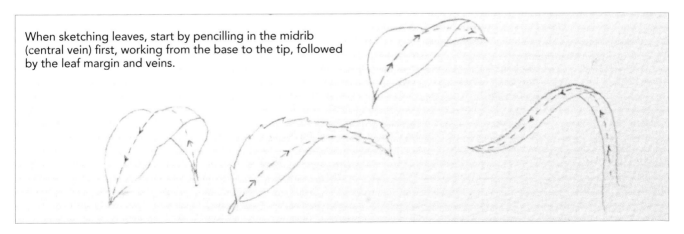

When sketching leaves, start by pencilling in the midrib (central vein) first, working from the base to the tip, followed by the leaf margin and veins.

Daffodil sketch

Surrounded by a variety of daffodils in spring I decided to paint a small selection. Before rushing in to a finished painting I decided to make an analytical sketch page, as having an understanding of a flower makes it much easier to portray.

I decided on my colour palette and proceeded to make studies, observing their structure, proportions, tonal variations and colour.

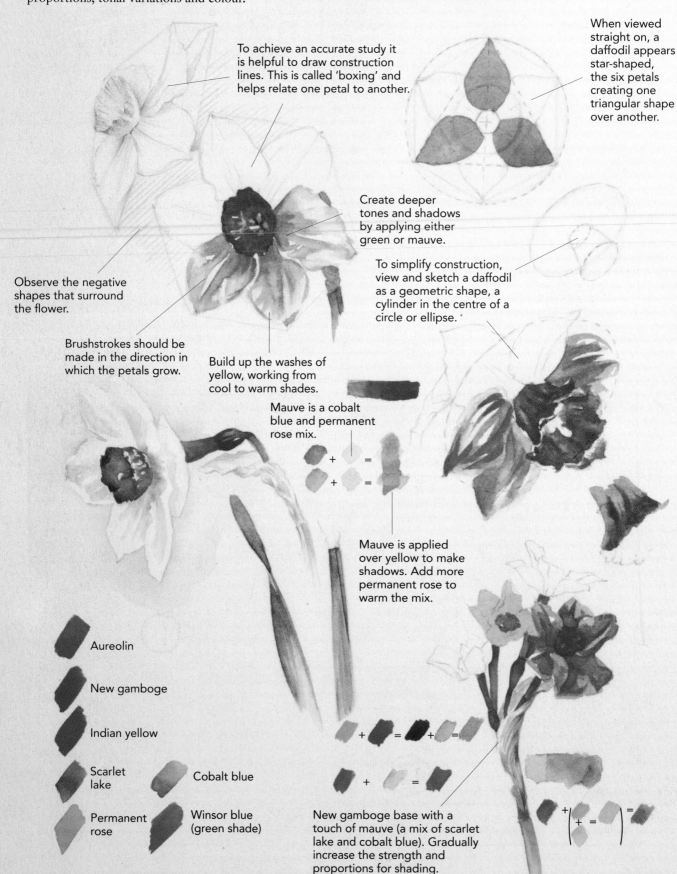

When viewed straight on, a daffodil appears star-shaped, the six petals creating one triangular shape over another.

To achieve an accurate study it is helpful to draw construction lines. This is called 'boxing' and helps relate one petal to another.

Create deeper tones and shadows by applying either green or mauve.

To simplify construction, view and sketch a daffodil as a geometric shape, a cylinder in the centre of a circle or ellipse.

Observe the negative shapes that surround the flower.

Brushstrokes should be made in the direction in which the petals grow.

Build up the washes of yellow, working from cool to warm shades.

Mauve is a cobalt blue and permanent rose mix.

Mauve is applied over yellow to make shadows. Add more permanent rose to warm the mix.

Aureolin

New gamboge

Indian yellow

Scarlet lake

Cobalt blue

Permanent rose

Winsor blue (green shade)

New gamboge base with a touch of mauve (a mix of scarlet lake and cobalt blue). Gradually increase the strength and proportions for shading.

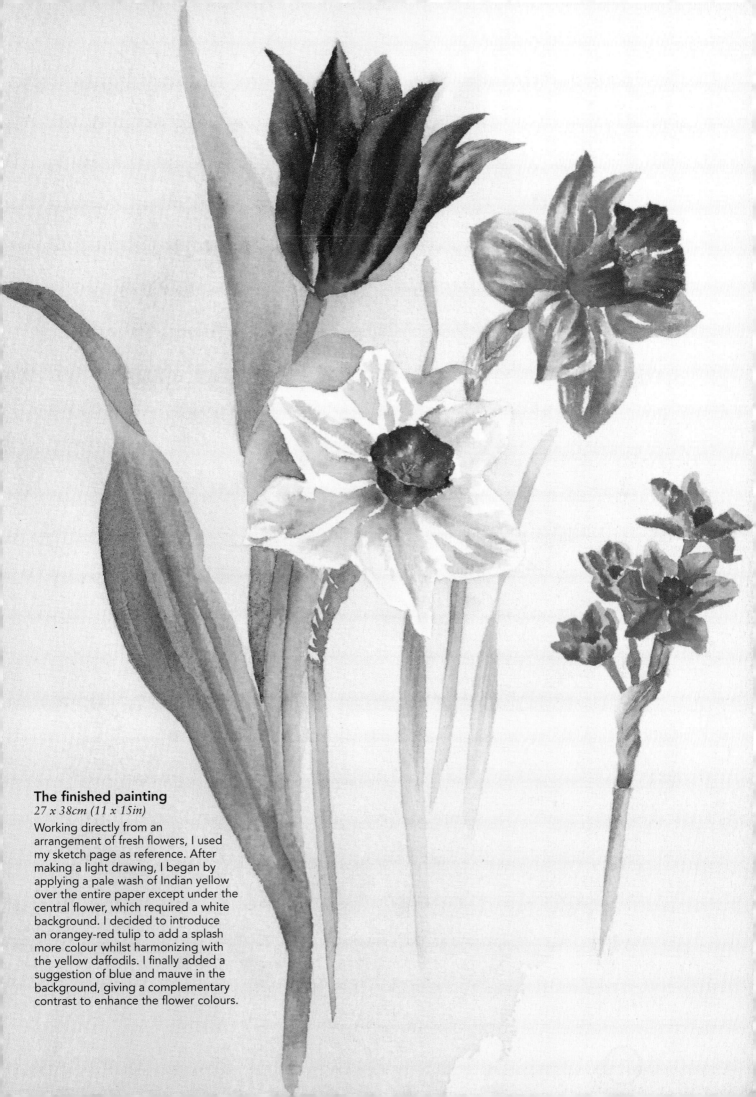

The finished painting
27 x 38cm (11 x 15in)

Working directly from an arrangement of fresh flowers, I used my sketch page as reference. After making a light drawing, I began by applying a pale wash of Indian yellow over the entire paper except under the central flower, which required a white background. I decided to introduce an orangey-red tulip to add a splash more colour whilst harmonizing with the yellow daffodils. I finally added a suggestion of blue and mauve in the background, giving a complementary contrast to enhance the flower colours.

Demonstrations

The beauty of painting flowers is their accessibility. Each season reveals new inspiration, from sparkling white snowdrops in winter to a vast range of wonderful colourful flowers in summer. There is nothing more pleasurable than painting from the real flower itself.

In this section I demonstrate my approach to painting using the techniques I have shown earlier in the book. If you work through them, it should assist in consolidating the skills used and I hope it will inspire you to select and paint fresh flowers of your choice.

I selected three or four flower types: clematis, with its double layer of petals creating a star shape; a rose forming a bowl shape with its many petals; and finally a combination of multiheaded spike-type delphiniums and stocks.

Before starting each painting, I made a small sketch to establish the composition before drawing it lightly in pencil on the water colour paper.

In the first painting, Clematis, the brightness of the stamens is retained using masking fluid, then the entire background is added. While wet, paint is dropped into the background to suggest the soft patches of the leaf and flower colours. The same technique is used for the petals, and diffused detail is created as this technique is combined with wet-on-dry gradated washes.

I took a different approach to the painting of Peace Roses, starting with the flower heads instead of the background. Rather than painting each individual petal, I wet the entire base of each flower head and dropped in touches of dilute colour, creating a soft transparent base of merging colours on which to work. The lavender was added into a wet background to give a diffused and less detailed appearance.

The final painting, Delphiniums and Stocks, uses a combination of techniques. I used masking fluid to retain the white paper under the stocks and painted a soft background of colours to help unify the painting. I then carefully painted each individual petal in the foreground delphinium, combining the wet-into-wet and wet-on-dry techniques as I worked. Plastic food wrap was used to suggest background delphiniums, while the soft shadows in the stocks were produced by glazing layers of dilute washes.

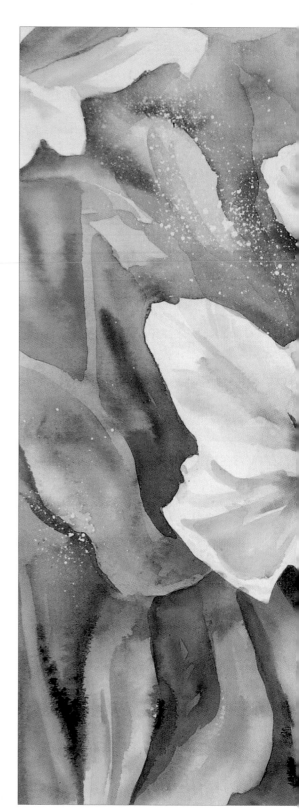

White Tulips

38 x 28cm (15 x 11in)

Once you have worked through the demonstrations to practise and consolidate the techniques covered in the previous sections, there is no reason why you should not tackle paintings like the one shown below.

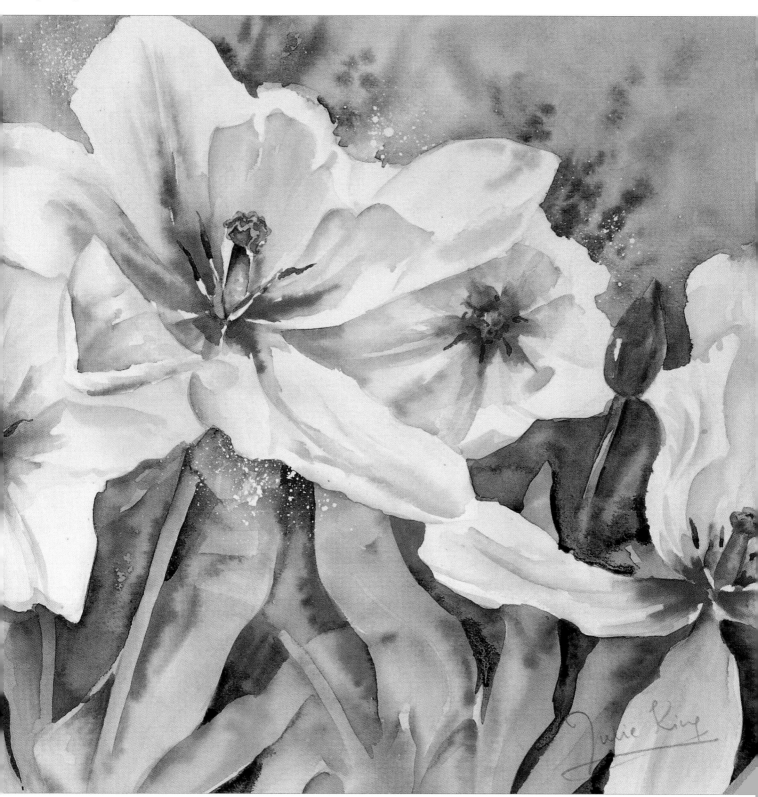

Clematis

A mass of these vibrant magenta star-like flowers caught my eye in late spring and I simply could not resist picking a few flower heads and leaves to paint.

My aim was to create a composition that gave the appearance of their entwined growth. The yellowy-green background with hints of soft pink complements the magenta flower heads whilst giving an illusion of depth.

You will need

Water colour paints: aureolin, quinacridone magenta, cobalt blue, new gamboge and Winsor blue (green shade)

Paintbrushes: size 12 Cotman III, 7/8 series 140 wash brush, size 7 Artist's Water Colour Sable

Not finish 300gsm (140lb) water colour paper, 23 x 28cm (9 x 11in)

Masking fluid and old brush

B pencil and eraser

1 Sketch out the picture with the B pencil, then apply masking fluid to the centres and stamens of the flowers.

Note

This photograph (left) is exaggerated to help show the main shapes. You should use a much lighter touch when drawing.

2 Prepare wells of quinacridone magenta, cobalt blue, aureolin and a pale green mix made with a combination of aureolin yellow with a touch of cobalt blue. Use the 7/8 series 140 wash brush to wet the whole paper, and then use the size 12 Cotman III to lay in a very thin wash of quinacridone magenta on and around the flower.

3 Drop in cobalt blue wet-into-wet in patches all over the picture.

4 Add touches of aureolin in the same way.

5 Still working wet-into-wet, apply the pale green around the flowerheads, taking it to the edges of the picture to suggest mottled foliage. Leave to dry thoroughly.

6 Make a blue-mauve mid-tone mix of cobalt blue with a little quinacridone magenta. Wet the bottom left petal of the main flower with the size 7 Artist's Water Colour Sable and apply the paint with downward brushstrokes working from the flower's centre to the tip.

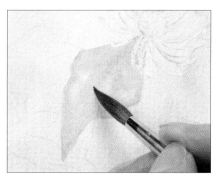

7 Using mainly quinacridone magenta with a little cobalt blue, make a pink-mauve mix and add touches wet-into-wet, leaving the blue-mauve base showing through to suggest highlights.

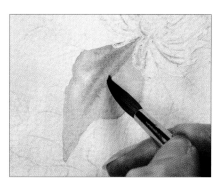

8 Use a strong wash of pure quinacridone magenta wet-into-wet, drawing vertical strokes downwards on either side of the petal's centre and leaving a gap to suggest a central vein.

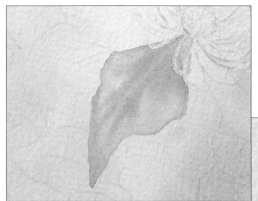

9 Add further touches of pure quinacridone magenta with the tip of your brush to suggest soft detailing and form. Allow the paint to dry completely.

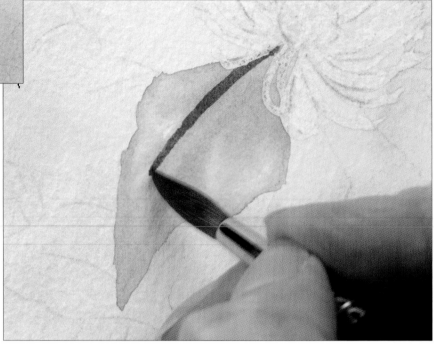

10 Strengthen the quinacridone magenta with swiftly-applied brushstrokes on the dry base, working from the centre and tapering off towards the tip.

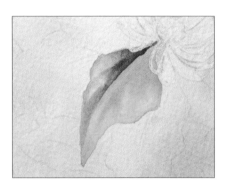

11 Quickly diffuse the paint away from the vein using clean water.

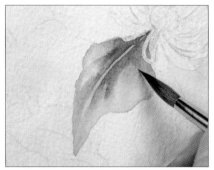

12 Leave a gap to suggest the central vein and repeat this on the other side. This completes the first petal.

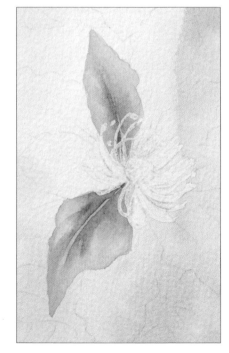

13 Working clockwise, skip a petal on the top layer and paint the top-most petal. Skipping a petal prevents the paint bleeding from one wet petal to another.

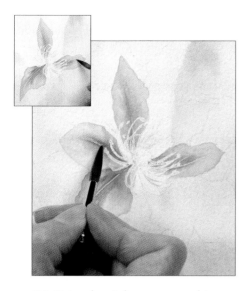

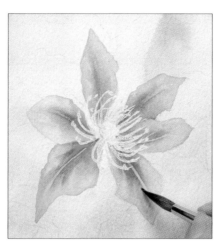

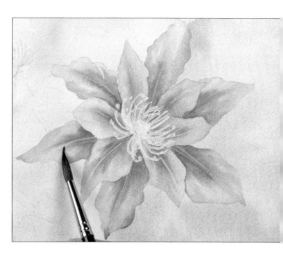

14 Paint the right-most petal in the same way (see inset). The paint on the first two petals will now be dry, so return to paint the left-most petal at this point.

15 Working clockwise, paint the remaining petals of the top layer and leave the painting to dry thoroughly before continuing.

16 Paint the lower layer of petals in the same way and leave to dry.

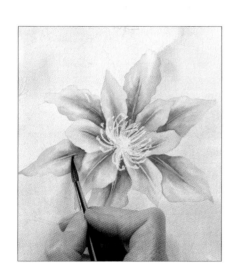

17 Use a fairly strong mix of quinacridone magenta wet-on-dry to add stronger details to both layers of petals, particularly in the deeper shadowed areas where petals overlap. Diffuse with clean water.

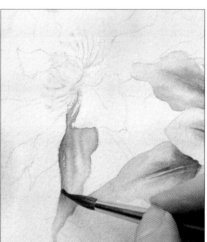

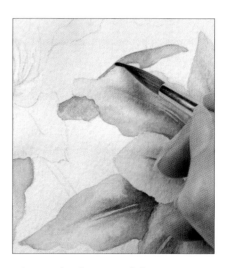

18 Wet the petal on the lower left of the left-hand flower and paint it using the mauve mixes and quinacridone magenta wet-into-wet. There is no need to detail it with stronger washes.

19 Wet both parts of the upper-right petal on the left-hand flower, and paint it with the same washes. Again, there is no need to add strong detail. Be careful not to paint over the petal that is partially obscuring it.

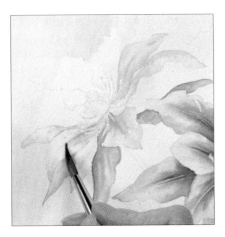

20 Paint the remaining petals of the left-hand flower, using slightly paler washes than the main flower.

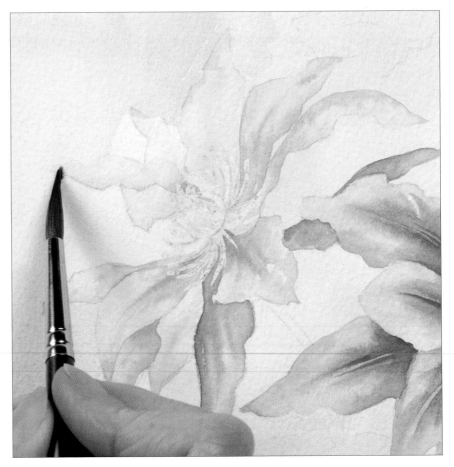

21 Working on a wet base, paint the final, top-most petals with even paler washes and virtually no detailing.

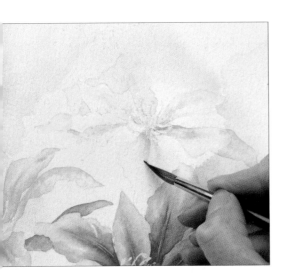

22 Use extremely dilute washes of the mauve mixes to paint the petals of the top-most flower.

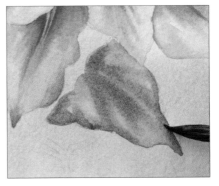

23 Make a pale green mix of new gamboge and cobalt blue. Use a size 7 brush to wet the right-most leaf and draw the green mix down the veins towards the tip as shown.

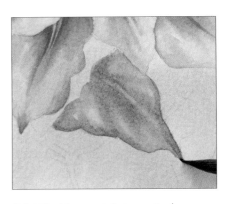

24 Working wet-into-wet, drop in a little Winsor blue (green shade) to strengthen the veins and allow to dry.

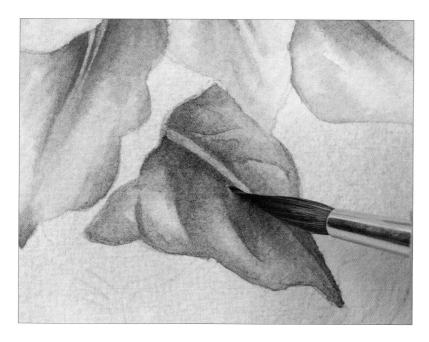

25 Add a tiny touch of quinacridone magenta to the green mix (new gamboge and cobalt blue) to deepen it slightly. Use this to paint veins and to give depth to either side of the central vein using wet-on-dry diffused wash effects.

26 Paint the top side of the central leaf in the same way and allow to dry. Vary the hue by altering the proportions of blue and yellow in the green mix.

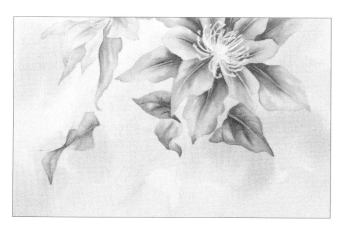

27 Use lighter tints of the same colours to paint the underpart of the central leaf and the left-most leaf.

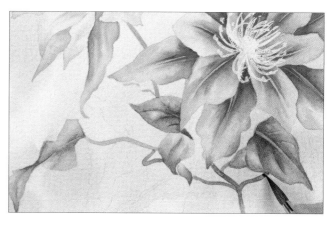

28 Use the green mix (cobalt blue and new gamboge) to paint in the stems wet-on-dry. Drop in quinacridone magenta mixed with Winsor blue (green shade) whilst wet to add shading and vary the colours.

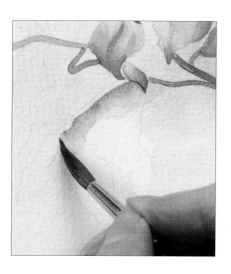

29 Using the green mix, begin painting the negative area around the background leaves, starting with the lowest ones. Apply paint wet-on-dry, then diffuse it into the background wash with water.

30 Drop in cobalt blue wet-into-wet to vary the hue.

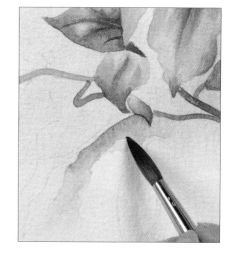

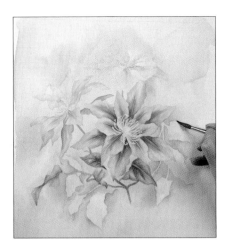

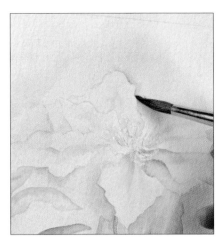

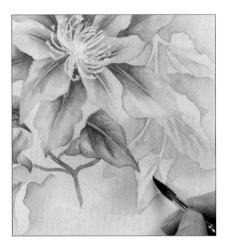

31 Continue the negative painting around the rest of the leaves.

32 Use the same green mix to add a little negative painting around the top flower, diffusing the green wash over the pink to help define the petals a little.

33 Use a pale green mix of new gamboge and cobalt blue to add subtle details to the negative leaves in the background.

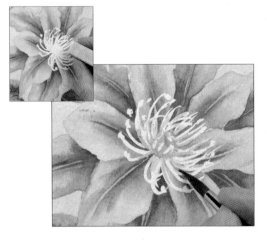

34 Rub off the masking fluid with a clean eraser (see inset), then use the size 7 Artists' Water Colour Sable with a mix of dilute new gamboge, cobalt blue and a tiny touch of quinacridone magenta to paint short strokes within the stamens.

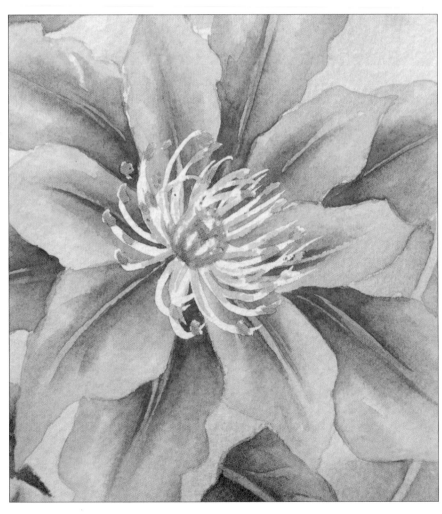

35 Mix a golden yellow by adding a touch of quinacridone magenta to new gamboge, and a mauve from equal amounts of quinacridone magenta and cobalt blue. Use the first mix of colours to paint the stamens and anthers, shading the golden yellow with the mauve.

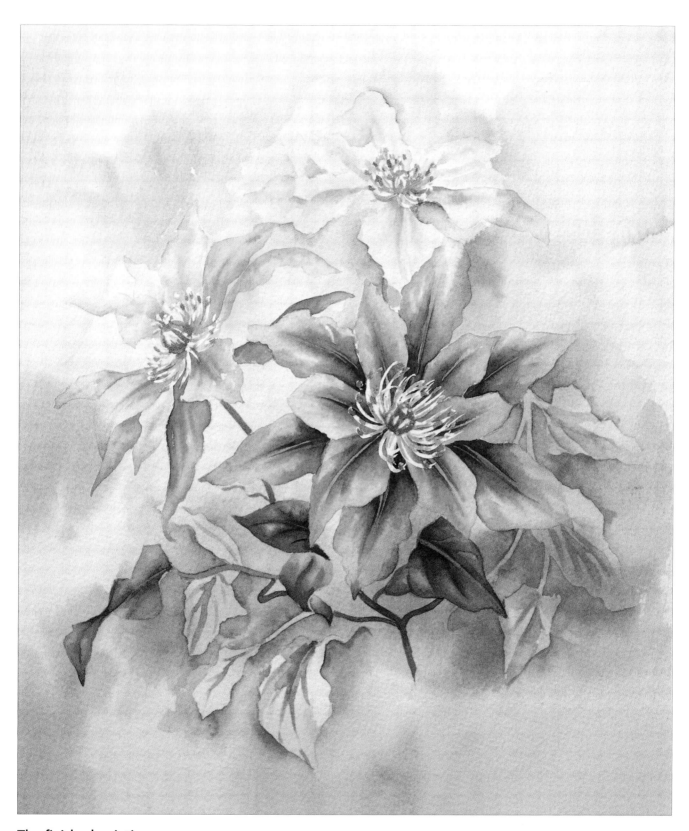

The finished painting

23 x 28cm (9 x 11in)

Any final details, such as strengthening the colours with dilute wet-on-dry glazes, can be added once the painting is completely dry.

Peace Roses

The rose is always a challenging subject so I hope this approach will assist you. I picked a delicate, beautifully-coloured specimen from my garden as the composition of three well-balanced blooms on a stem was perfect to paint. A country garden look is achieved by combining lavender with the roses, and this requires only a simple soft diffused background to enhance the flowers.

You will need

Water colour paints: aureolin, new gamboge, permanent rose, quinacridone magenta, scarlet lake, cobalt blue and French ultramarine

Paintbrushes: size 8 Cotman, size 12 Cotman III and size 7 Artist's Water Colour Sable

Not finish 300gsm (140lb) water colour paper, 25 x 35cm (9¾ x 13¾in)

B pencil

1 Sketch out the picture with the B pencil as shown. Prepare wells of aureolin yellow, new gamboge, permanent rose, quinacridone magenta and scarlet lake.

2 Wet the large rose with the size 12 brush and apply touches of aureolin yellow, concentrating on the centre and being careful not to go over the outside lines.

3 Add touches of new gamboge in and around the centre and recessed areas.

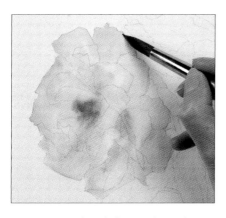 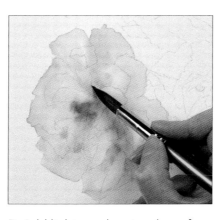 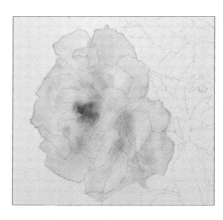

4 Continue by defining the edges of the petals, adding permanent rose wet-into-wet. Allow the colours to diffuse towards the centre of the flower.

5 Add light, random touches of scarlet lake wet-into wet into the recesses and shaded parts.

6 Add quinacridone magenta wet-into-wet into the cooler petals, then allow to dry.

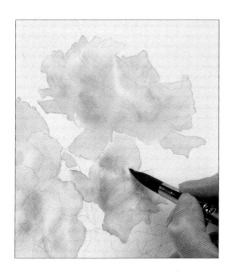

7 Paint the top flower in the same way, then paint the bud below it using a slightly stronger wash of permanent rose towards the centre to give a warmer, richer hue.

8 Using the gradated wash technique wet-on-dry, paint the area of background below the bottom leaves with new gamboge, then quickly diffuse the paint away from the pencil outlines with a clean wet brush to fade the paint into the white of the paper.

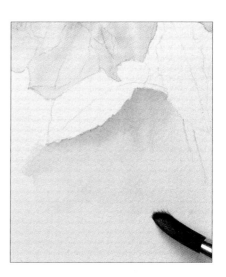

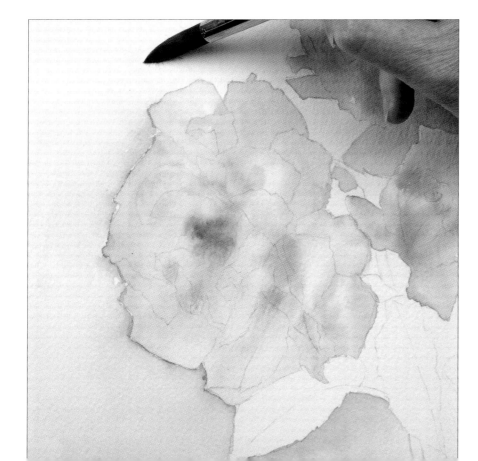

9 Working clockwise round the flower head, continue adding paint and diffusing it, working in sections to avoid a patchy finish. Prepare a mix of blue-mauve (cobalt blue with a little permanent rose); pink-mauve (permanent rose with a little cobalt blue); and a pale green mix (cobalt blue and new gamboge).

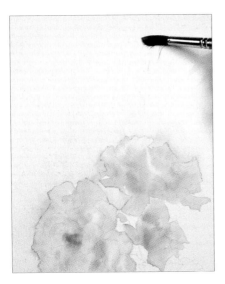

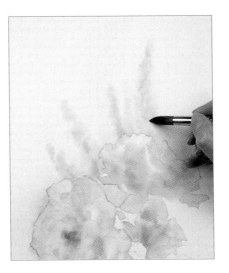

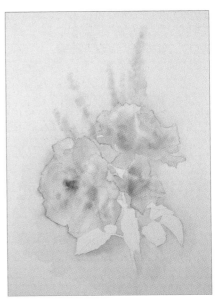

10 Continuing around the top flower, diffuse the yellow as before, but take it up above the lavender as shown. Keep the yellow very dilute to avoid muddying the next stages.

11 Use the two mauve mixes wet-into-wet with a dotting motion of the tip of your brush to suggest lavender flowers. Add the green mix wet-into-wet near the centre of the spikes.

12 Continue working clockwise to fill in the rest of the background, including the areas between the flowers and leaves.

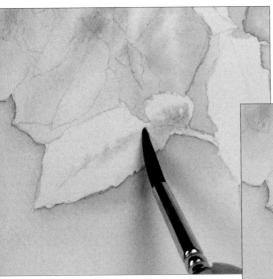

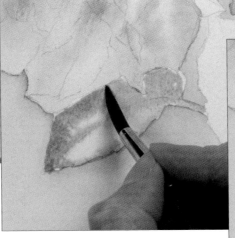

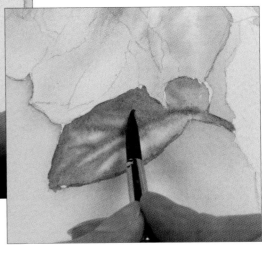

13 Prepare wells of French ultramarine, new gamboge and a warm green mix of the two. Wet the left-most leaf and add French ultramarine over the area shown, using a size 8 brush.

14 Add new gamboge wet-into-wet to the other half and along the margins of the leaf. Allow the colours to bleed together.

15 Still working wet-into-wet, run the green mix down the central vein between the two colours, and suggest side veins with short strokes using the tip of the brush. Allow to dry.

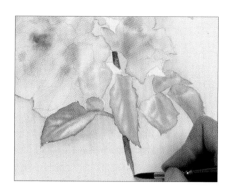

16 Paint the other leaves with the same mixes, then paint the stem of the rose with the green mix and shade it with a maroon mix made up of scarlet lake with a touch of French ultramarine.

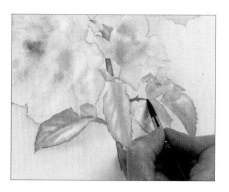

17 Paint the sepals and leaf stems in the same way as the leaves but add a little more maroon wet-into-wet at the ends.

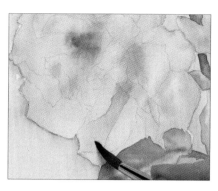

18 Prepare wells of permanent rose, quinacridone magenta and new gamboge, and use a size 7 brush to lay in some permanent rose wet-on-dry in the inside of the bottom petal. Diffuse this across the petal as shown.

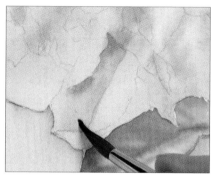

19 Glaze new gamboge into the wet base to warm and vary the tone at the top of the petal, and quinacridone magenta to cool the bottom of the petal.

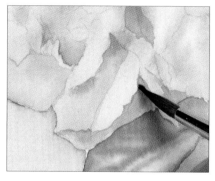

20 Continue to paint around the light petals which appear to curl towards you, leaving some petals purely with the base colour and adding depth and form to others with the colours from steps 18 and 19.

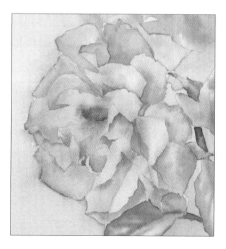

21 Continue painting the petals one by one to complete the flower. Work slowly and carefully, using your sketch lines to work out where you should shade.

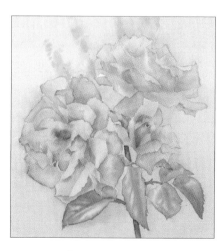

22 Paint the other flowers and the bud in the same way.

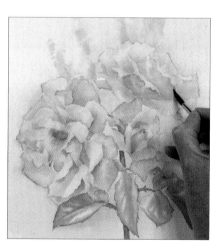

23 Use a clean eraser to remove the pencil lines, then use the same mixes to make any adjustments to the roses.

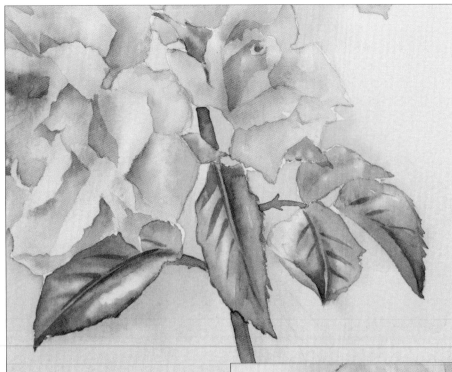

24 Mix a green of new gamboge and French ultramarine, and use this to suggest the veins on the leaves. Use the maroon mix (scarlet lake with a touch of French ultramarine) to add red hints to the edges of the leaves.

25 Stipple (using the tip of the brush to drop dots of paint) a mix of new gamboge with a touch of scarlet lake in the centre of the main flower, then use a little cobalt blue mixed with permanent rose to make a mauve. Use this to stipple on top, allowing the colours to bleed together, creating a deeper tone.

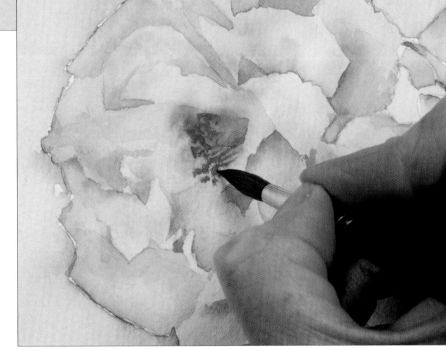

Opposite
The finished painting
25 x 35cm (9¾ x 13¾in)
Complete the painting by adding subtle details and faint stems to the lavender.

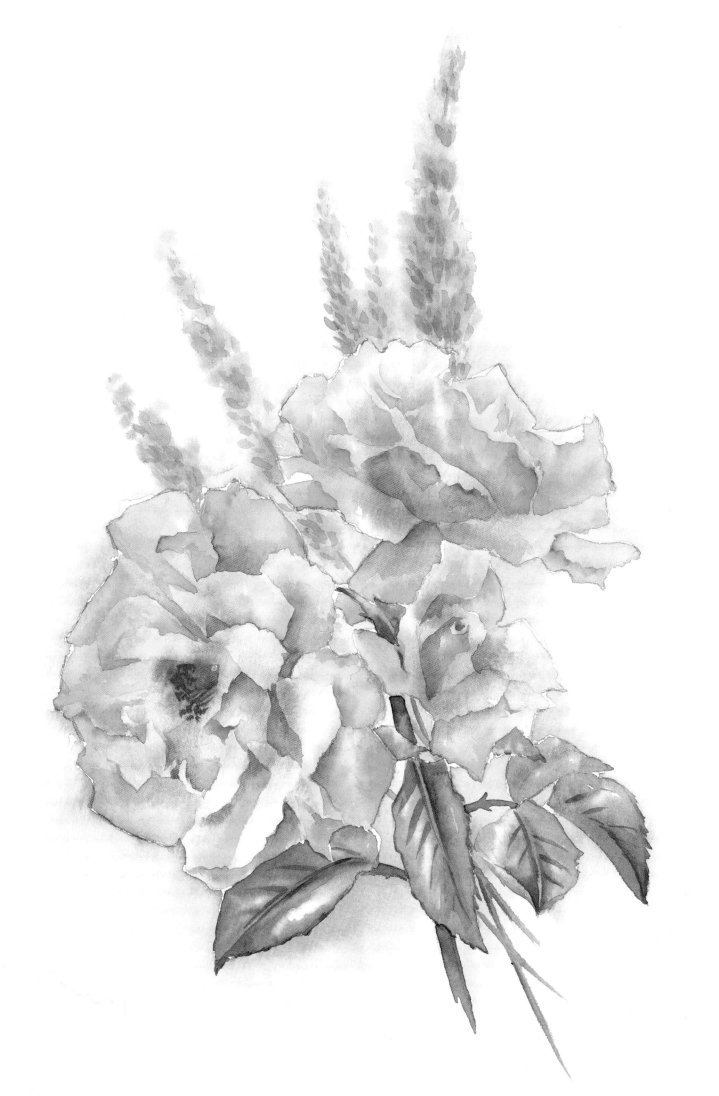

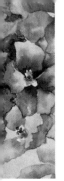

Delphiniums and Stocks

I am always attracted to the beautiful rich blues of the delphinium. For this painting, I placed them in a tall vase and added contrast with white stocks.

I set out to evoke the atmosphere of a garden scene by suggesting blooms in the background and by emphasising the foreground leaves with negative painting.

The yellow-green mix in the background complements the blue-mauves of the flowers and enhances their colour.

You will need

Water colour paints: French ultramarine, cerulean blue, Winsor blue (green shade), quinacridone magenta, new gamboge and aureolin

Paintbrushes: size 7/8 series 140 mop and size 16 Cotman III

Not finish 300gsm (140lb) water colour paper, 35.5 x 50.7cm (14 x 20in)

Plastic food wrap

Masking fluid and old brush

B pencil

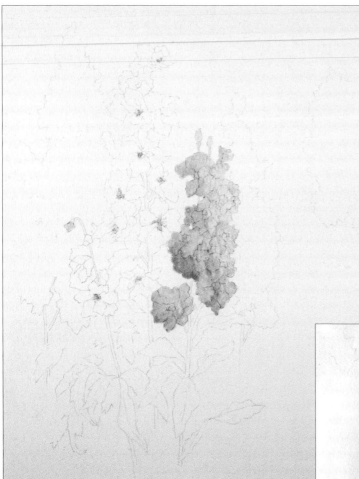

1 Sketch the flowers with the B pencil, then apply masking fluid to mask off the stocks and the centres of the forward-facing delphiniums as shown. Prepare some wells of French ultramarine, cerulean blue, aureolin and a green mix of French ultramarine and aureolin.

2 Wet the background with the size 7/8 series 140 mop brush and use the size 16 Cotman III brush to lay dilute French ultramarine over the flowers, including the patch on the right.

3 Add touches of cerulean blue wet-into-wet around the masked areas as shown.

4 Drop in aureolin in the gap between the areas of flowers and across the lower half, allowing the paint to bleed into the blues to create green hues.

5 Add the green mix wet-into-wet across the lower left side, behind the foliage. Allow to dry.

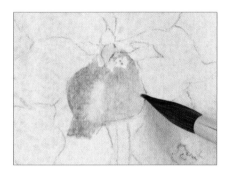

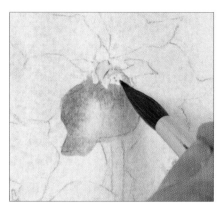

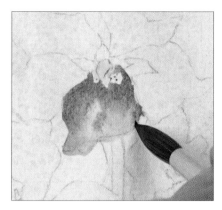

6 Prepare wells of French ultramarine, Winsor blue (green shade), and a purple mix of French ultramarine and quinacridone magenta. Use the size 7 brush to wet one of the delphinium petals and drop in French ultramarine, gently drawing the colour down from the centre to the tip.

7 Add Winsor blue (green shade) wet-into-wet to vary the hue.

8 Still working wet-into-wet, add the purple mix near the centre and edges of the petal.

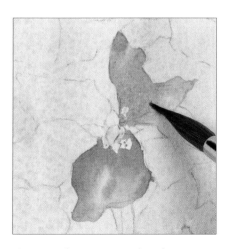

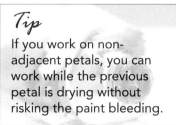

Tip
If you work on non-adjacent petals, you can work while the previous petal is drying without risking the paint bleeding.

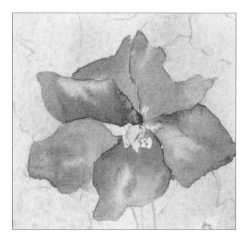

9 Paint the next petal in the same way, varying the tones.

10 Paint the remaining petals of the flower in the same way.

11 Varying the tones as you go, paint the other flowers on the foreground delphinium, being careful not to work next to wet petals – allow each to dry thoroughly. Use slightly lighter tints for the flowers further away.

Tip

Remember that diluting your wash is a simple way to make a lighter tone.

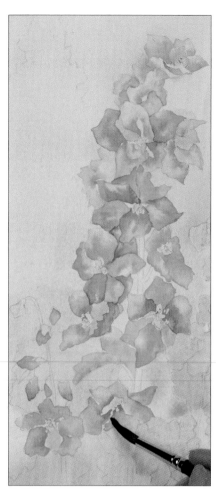

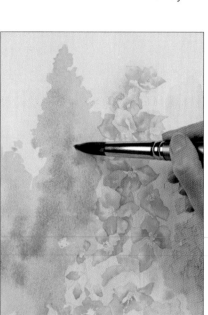

12 Paint the background delphiniums on the left by using a size 16 brush with softer tones of French ultramarine. Add Winsor blue (green shade) wet-into-wet around the middle of the area to add interest.

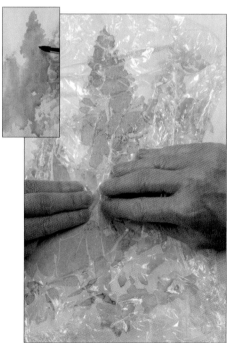

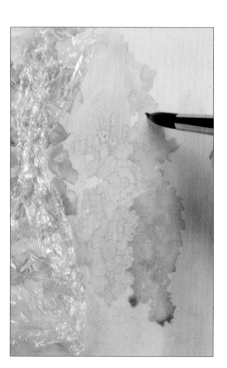

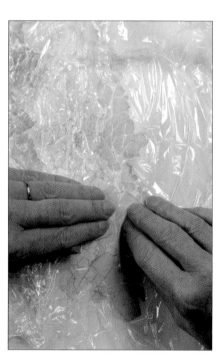

13 Add quinacridone magenta (see inset), then lay wrinkled plastic food wrap over the wet area, and pinch it into shape as shown.

14 Repeat the painting process on the pink central delphiniums, using more quinacridone magenta to give a slightly redder hue.

15 While wet, lay wrinkled plastic food wrap over the wet area. Pinch the wrap to make smaller geometric shapes than the first section. This will make the area appear more distant.

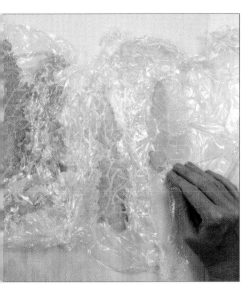

16 Use a very faint tone of French ultramarine on the right-most delphiniums and repeat the process.

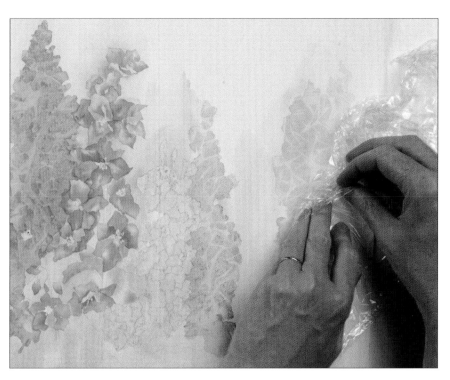

17 Leave the paint to dry thoroughly (this will take longer than normal owing to the plastic covering it), then carefully remove the food wrap to reveal a textured surface on the background delphiniums.

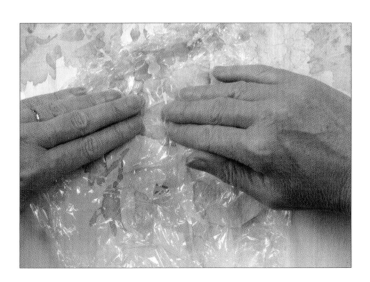

18 Make a green mix of new gamboge with a smaller amount of French ultramarine and use the size 16 brush to paint around the negative areas of the main leaf shapes of the foliage. Drop in pure French ultramarine to vary the colour, then lay plastic food wrap over as before.

19 Use a size 7 brush to outline the leaves on the right of the foliage with the green mix, then use clean water to diffuse the wet paint into the background.

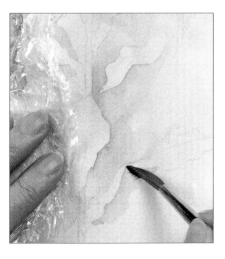

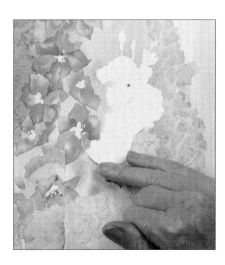

20 When dry, carefully remove the food wrap and rub the masking fluid away with your fingers.

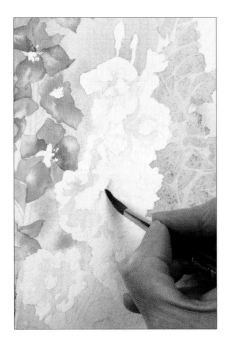

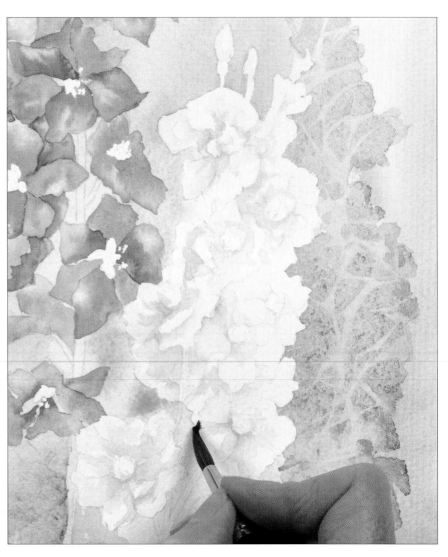

21 Prepare a well of aureolin and mix a purple-grey from French ultramarine with touches of quinacridone magenta and aureolin. Working from the centres outwards, use a size 7 brush to apply a very dilute tint of aureolin to the stocks, whilst leaving sufficient white areas to suggest a glow of light on the petals.

22 When dry, use the purple-grey mix in the recesses of the stocks and diffuse out with clean water to form a glaze over areas of the yellow and white petals. This will add definition and modelling.

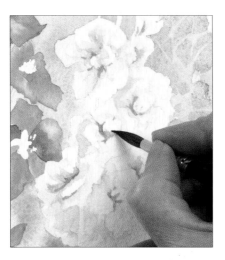

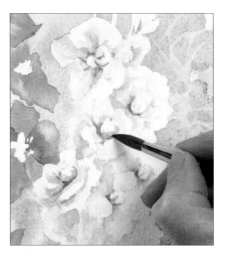

Tip
Applying dilute washes of different colours wet-on-dry is called glazing, and is a good way to strengthen tone without risking muddying the paints.

23 Use the green mix to define the centres of the stocks by painting it wet-on-dry into the deepest recesses and diffusing it with clean water.

24 Once dry, continue using the same mixes to strengthen the colours of all the flower heads.

25 Use a touch of the green mix to paint the centres of the delphiniums, leaving small white spaces. Allow to dry, then use a stronger green mix with touches of the grey-purple wet-into-wet to detail the centres.

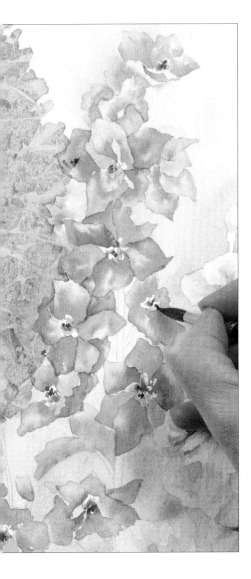

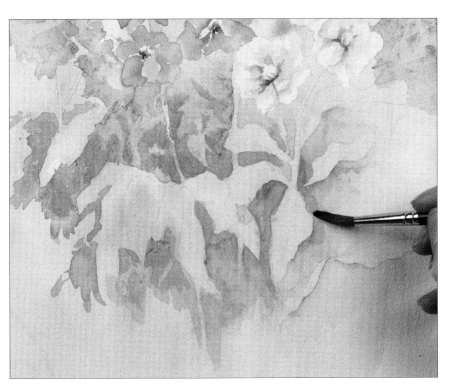

26 Add more new gamboge to your green mix, then use this with a size 7 brush to develop the foliage shapes created by the food wrap at the bottom of the painting, to suggest deeper background foliage.

27 Make up two new green mixes; one with more French ultramarine, and one with more new gamboge. Use the yellow-green to begin modelling one of the leaves, leaving the base colour showing to suggest the direction of the veins.

28 Drop in the blue-green wet-into-wet and allow the colours to bleed together on the leaf.

29 Paint the other leaves in the same way.

30 Make a second well of the yellow-green mix and add quinacridone magenta to make a pinky-green. Use the pinky-green mix along with the original yellow-green to paint all of the plant stems. Shade and vary them with the blue-green mix.

31 Apply more strength towards the centres of the main flower heads, working wet-on-dry and diffusing the paint with clean water. Suggest some deeper petal edges on the shaded (left-hand) side of the foreground delphiniums with French ultramarine and quinacridone magenta. Add a tiny amount of new gamboge to the mix to make a deeper tone and vary the hue further with Winsor blue (green shade).

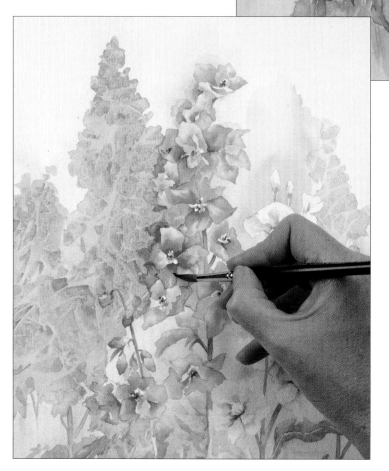

Opposite
The finished painting
35.5 x 50.7cm (14 x 20in)
At this point, the painting is complete, but feel free to add any details you feel necessary. I have accentuated the stems with stronger negative painting and added subtle dark blue areas in the background delphiniums.

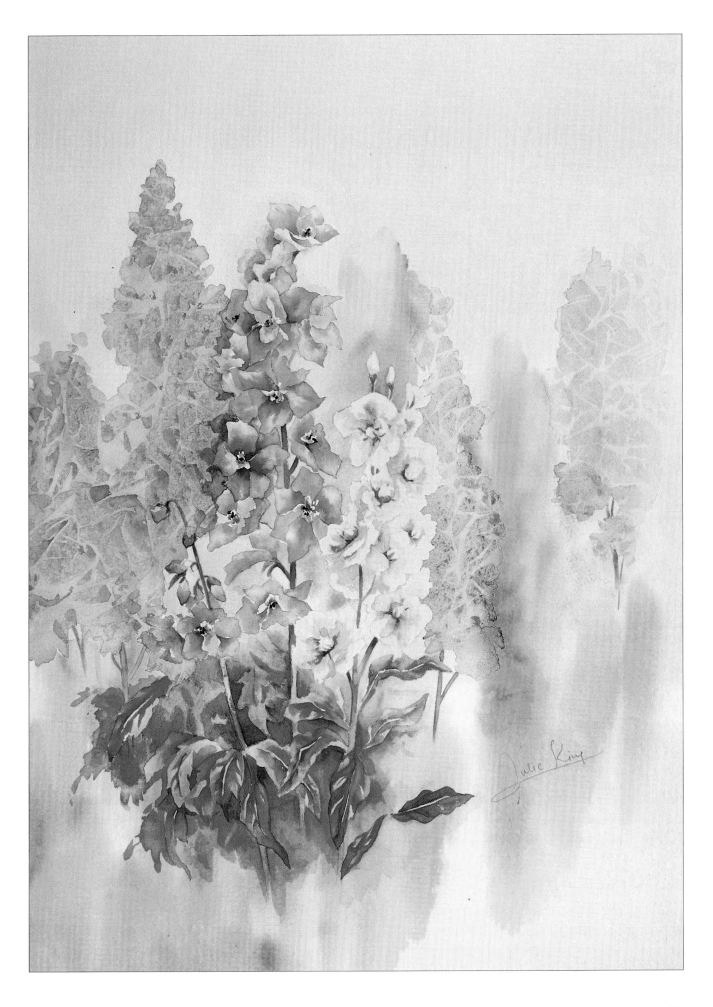

Index

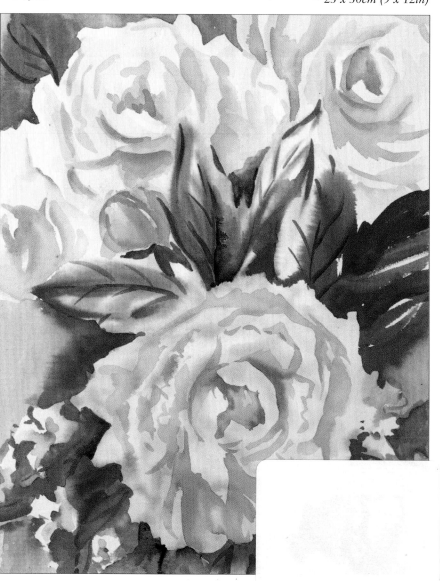

Peonies
23 x 30cm (9 x 12in)